IMAGES
of America

LOS ANGELES'S
LA BREA TAR PITS
AND HANCOCK PARK

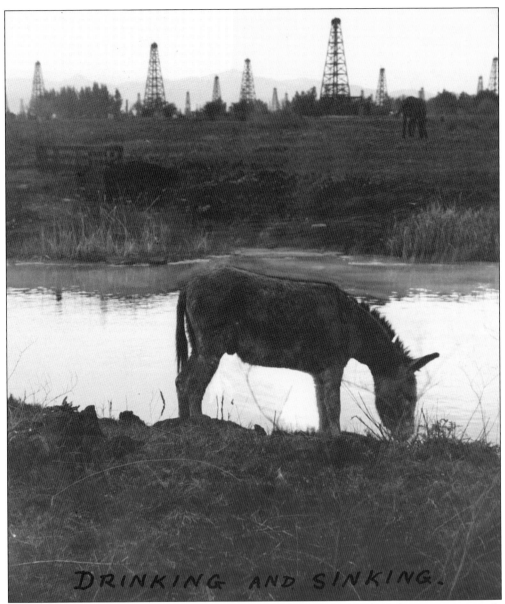

DRINKING AND SINKING.

This humorous magic-lantern slide, titled "Drinking and Sinking," dates from approximately 1910. In the early part of the 20th century, Rancho La Brea was located well outside urban Los Angeles. The slide shows donkeys grazing next to Oil Lake (now replaced by the Page Museum parking lot), with the Hollywood Hills and oil wells in the background. (Natural History Museum of Los Angeles County [NHM], Museum Archives.)

ON THE COVER: The fossil-digging done by the Los Angeles County Museum from 1913 to 1915 left depressions in the ground at the old excavation sites that quickly filled with tar and created the famous La Brea tar pits. The first landscaping of Hancock Park, completed in the 1930s, enclosed the pits with low stone walls. The attractive walls did little to keep visitors away from the asphalt. (NHM, Museum Archives.)

IMAGES
of America

LOS ANGELES'S
LA BREA TAR PITS
AND HANCOCK PARK

Cathy McNassor

ARCADIA
PUBLISHING

Published by Arcadia Publishing
Charleston, South Carolina

Printed in the United States of America

Library of Congress Control Number: 2011926199

For all general information, please contact Arcadia Publishing:
Telephone 843-853-2070
Fax 843-853-0044
E-mail sales@arcadiapublishing.com
For customer service and orders:
Toll-Free 1-888-313-2665

Visit us on the Internet at www.arcadiapublishing.com

This book is dedicated to George Allan Hancock and George C. Page for making it all possible.

CONTENTS

ACKNOWLEDGMENTS

Many individuals have been instrumental in making this book happen. First and foremost, I must thank Dr. William Estrada for coming up with the idea. My colleagues in the history department were beyond helpful, and I thank John Cahoon, Kristen Hayashi, Brent Riggs, Betty Uyeda, and Beth Werling for their assistance.

The staff of the George C. Page Museum contributed to this effort, and I would like to thank Margi Bertram, Shelley Cox, Aisling Farrell, Carrie Howard, Christina Lutz, Gary Takeuchi, Christopher A. Shaw, and Trevor Valle.

I am very grateful to the staff members of the Natural History Museum of Los Angeles County (NHM) who have assisted me with this project. Jim Gilson reviewed contracts and photographs, Richard Hulser located research materials, John Long provided approval, Terri Togiai took care of accounting, and Trino Marquez and Robert Reid posed for photographs. Volunteers Jessica Roussel and Diane Stewart were very helpful, and I would especially like to thank museum trustee Betty Reddin for her support.

Debbie Seracini and Jerry Roberts of Arcadia Publishing walked me through the process of creating this book, and they deserve much of the credit for it. John Sullivan of the Huntington Library helped by adjusting photograph quality. Erica Varela of the *Los Angeles Times* helped locate photographs.

There have been several gifts of photographs to the Page Museum Archives that I would like to acknowledge. The donors are as follows: the J.Z. Gilbert family, John M. Phillips, Richard Pierce, Jack Weinger, and Bonnie Dorsey Shinski.

Fred Truxal contributed the Paul Conrad cartoon, and I am honored that David P. Conrad gave permission to include it in the book. David and Vera Packard allowed me to copy their scrapbook, and Phil Ritchie granted consent to use his father's photograph of David Packard. Phil Noyes and Huell Howser gave permission to use Huell's image. I truly appreciate that John Haan granted authorization to include him.

The following individuals provided photographs for this book: Mary Alice Orcutt Henderson of the Santa Paula Historical Museum, Brett Arena of A.F. Gilmore Company, Robin Turner of ArchaeoPaleo Resource Management, Kathleen Fahey of the Wellesley Historical Society, Simon Elliott of the University of California, Los Angeles (UCLA) Library Special Collections, Maia November of Los Angeles County Museum of Art (LACMA), Letha E. Johnson and Rebecca Shulte of the University of Kansas Libraries, and my dear friend Jane Brennan.

Lastly, I would like to thank my husband, John M. Harris, for his expert editing and patience.

INTRODUCTION

For over a century, the world-famous La Brea tar pits have captured popular imagination and excited both scientists and the public. This unique view into the last Ice Age, as documented by fossils preserved by asphalt, is located near the center of what is now the city of Los Angeles, California. The remains of extinct saber-toothed cats, ground sloths, and dire wolves present a picture of a very different group of inhabitants that occupied this area until around 10,000 years ago. This book will explore the history of this amazing site and the people who helped to preserve and promote this unique fossil treasure.

The first European to mention the asphalt seeps at Rancho La Brea was a Spanish priest, Fr. Juan Crespi, who chronicled the expedition mounted by Gaspar de Portola in 1769 in search of sites for new missions. Father Crespi described springs of bubbling pitch that came up from the ground and noted earthquakes in the same area. In 1781, El Pueblo de Nuestra Senora la Reina de Los Angeles was officially founded under the flag of Spain. In 1821, Mexico gained independence from Spain, and the Spanish territories then came under Mexican rule. In 1828, the large area west of the pueblo was granted to Antonio Jose Rocha and Nemesio Dominguez by the alcalde, or mayor, of Los Angeles, Jose Antonio Carillo. One of the conditions of the land grant was that the citizens of Los Angeles were to be allowed to take as much of the *brea*, or pitch, that oozed from the ground as they needed for their personal use. The asphalt from the tar seeps was mostly used for roofing, but in prehistoric times, Native Americans used it as an adhesive and to waterproof canoes and baskets.

After the conclusion of the war between the United States and Mexico, California was annexed to the US and became the 31st state in 1850. The property of Rancho La Brea became embroiled in a legal fight for ownership that lasted for over 20 years. The Rocha family claimed the land but ended up in a major court battle due to the provisional nature of the original Mexican land grant and the unclear boundaries of the property. The Rochas took their case all the way to the US Supreme Court and won, but by that time, much of the property had been sold to cover the legal expenses. By the early 1870s, most of the original land grant had been dispersed, and the ownership of the property so was complicated that it took years to straighten out the various claims. The brothers John and Henry Hancock obtained adjoining sections of the rancho by the 1870s, with Henry acquiring the portion with the asphalt seeps.

Henry Hancock was a Harvard-educated lawyer from New Hampshire who had achieved the rank of major in the war with Mexico. He arrived in San Francisco as a young man in 1849 and soon migrated south to Los Angeles where he began a career as a lawyer and surveyor, mapping much of Los Angeles for the US Surveyor's Office. By the time Hancock acquired his portion of Rancho La Brea, he was a prominent citizen of the city and had served in the California State Assembly. On land directly north of what is now Wilshire Boulevard, Hancock operated a commercial asphalt mine. There are several accounts of bones being dug up in the process of mining asphalt, but they were considered to be remains of modern domestic animals and discarded.

In 1875, the English geologist and spiritualist Prof. William Denton visited the rancho, and Major Hancock presented him with what turned out to be a canine tooth of an extinct saber-toothed cat. Denton also collected bones and teeth of an extinct horse and several other animals, and he was apparently the first person to recognize that the bones from the asphalt deposits of Rancho La Brea were fossils. Denton's short article on his findings in the *Proceedings of the Boston Society of Natural History* went largely ignored by the scientific community.

Henry Hancock died in 1883, leaving his widow, Madame Ida Hancock, with two young sons and his portion of Rancho La Brea to manage. Squatters beset the property, and Ida entered into a long and expensive court battle to evict them and regain clear title to the rancho. Throughout this time period, the farming and mining operations of Rancho La Brea were her sole means of support, and she was "land poor." Her financial situation changed dramatically after the turn of the century when the oil beneath the rancho made Ida and her surviving son, George Allan, very wealthy.

By 1901, Rancho La Brea was being explored for its potential as an oil-producing site, and the fossils once again attracted attention. Petroleum geologist W.W. Orcutt recognized the tar-soaked bones as fossils and collected a sample of them in 1901. Orcutt tried to convince Stanford University, his alma mater, to excavate at the site, but Stanford declined to do so because of lack of resources and referred him to the University of California, Berkeley. In 1906, the first fossil excavation at Rancho La Brea was undertaken by the University of California under the direction of renowned paleontologist John C. Merriam. The dig yielded hundreds of fossils, and in 1908, Merriam published his first popular article on La Brea, entitled "Death Trap of the Ages," in *Sunset* magazine. This article, with its account of the strange extinct animal fossils found in the tar pits, popularized the site and helped to create the fascination with Rancho La Brea that continues to the present.

After the pioneering work by the University of California, several institutions—among them Los Angeles High School, Occidental College, and the Southern California Academy of Sciences—collected fossils at Rancho La Brea. In 1913, George Allan Hancock granted the exclusive right to dig on the property to the newly founded Los Angeles County Museum of History, Science, and Art. Hancock later offered to donate the 23 acres that contained the richest fossil deposits to the County of Los Angeles in 1916, but the gift was not finalized because of the many improvements that were stipulated in the deed and the outbreak of World War I. Hancock's intention always was to preserve the land and its extraordinary fossil beds as a scientific resource for future generations. When the gift of the land to the county was finalized in 1924, the property became Hancock Park.

Hancock Park is one of the most unusual tourist destinations in Los Angeles and is the site of two major museums: the George C. Page Museum of La Brea Discoveries and the Los Angeles County Museum of Art. The Rancho La Brea tar pits are recognized as one of the world's richest Pleistocene, or Ice Age, fossil sites and the only one that is located in a major city. The site was designated as a national natural landmark in 1964 by the US Department of the Interior.

This book tells the story of how the La Brea tar pits and Hancock Park became what they are today and chronicles the people and events that were a significant part of this history.

One

EARLY YEARS
PREHISTORY AND HISTORY

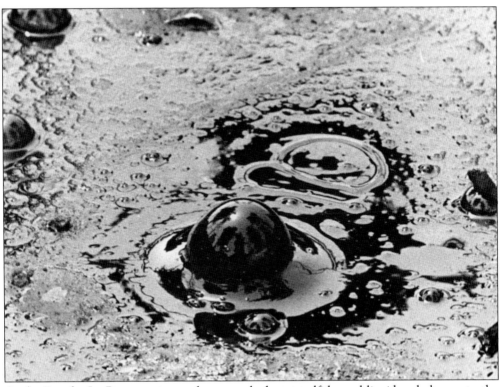

At the Rancho La Brea tar pits, methane gas, hydrogen sulfide, and liquid asphalt seep to the surface through cracks in the earth. Some of the seeps display bubbles, such as this one, as the rising asphalt reaches the open air. These tar seeps can occur in the same place for many years, forming the mounds of hardened asphalt known as "tar volcanoes." (Page Museum Archives.)

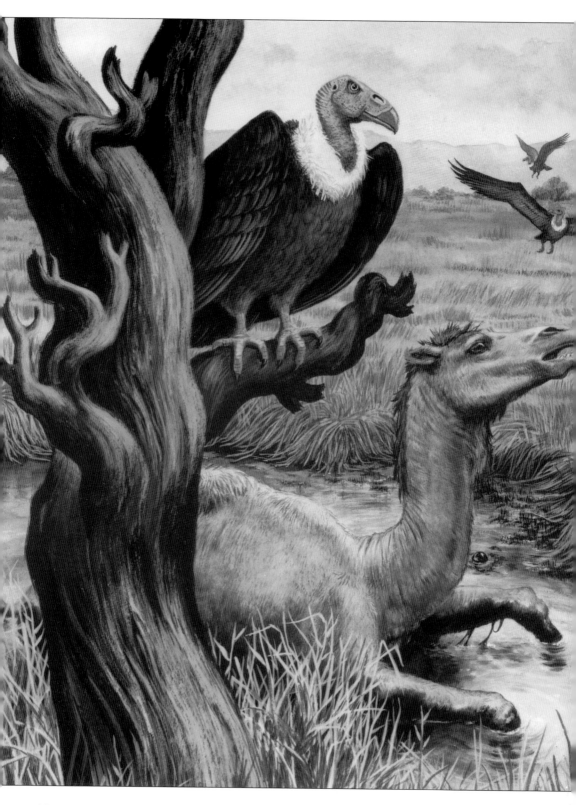

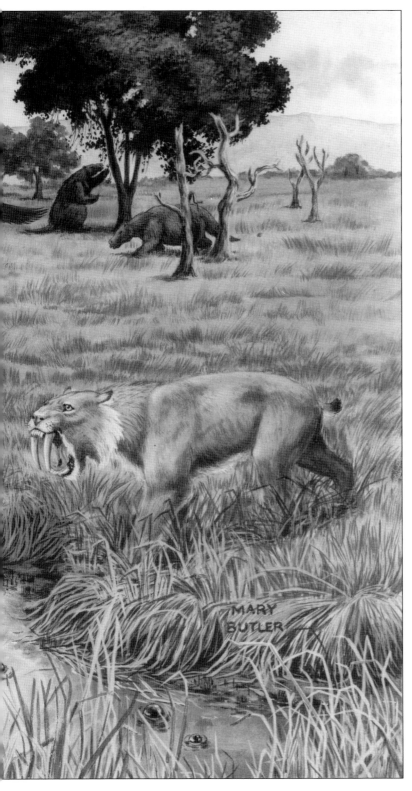

MARY
BUTLER

From 50,000 to 11,000 years ago, this scene of entrapment occurred often at La Brea. Here, a camel is trapped in tar, with a giant condor-like teratorn and a saber-toothed cat attracted by the easy prey. The asphalt is very sticky, and the predators would also become mired when they attacked the struggling victim and become victims themselves. The bones of the trapped animals were permeated and preserved by the tar and were later covered with sediment that washed down from the mountains during the winter rains. If this type of event even occurred only once in 10 years, it would account for the huge number of fossils found at the La Brea tar pits. (Page Museum Archives, Mary Butler painting.)

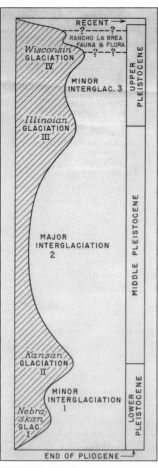

RECENT →

--?-----?--

RANCHO LA BREA
FAUNA & FLORA

--?---?--

Wisconsin GLACIATION IV

MINOR INTERGLAC. 3

UPPER PLEISTOCENE

Illinoian GLACIATION III

MAJOR INTERGLACIATION 2

MIDDLE PLEISTOCENE

Kansan GLACIATION II

MINOR INTERGLACIATION 1

Nebraskan GLAC. I

LOWER PLEISTOCENE

END OF PLIOCENE →

This diagram, showing glacial and interglacial stages of the Pleistocene Ice Age and the possible position of the Rancho La Brea occurrence in this sequence, appeared in the sixth edition of Chester Stock's *Rancho La Brea, a Record of Pleistocene Life in California.* Now, it is known that the sequence of climatic changes during the Ice Age was more complex than depicted in this diagram. (Page Museum Archives.)

This diagram, from the 1930 edition of Chester Stock's *Rancho La Brea, a Record of Pleistocene Life in California,* shows asphalt seeping to the surface through cracks and fissures in the Earth's surface. The area sits on top of a vast underground pool of oil, known as the Salt Lake Oil Field, and is adjacent to the Sixth Street earthquake fault. (Page Museum Archives.)

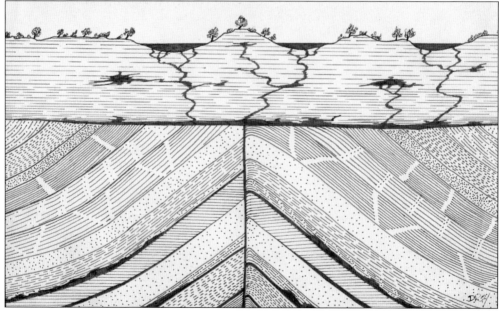

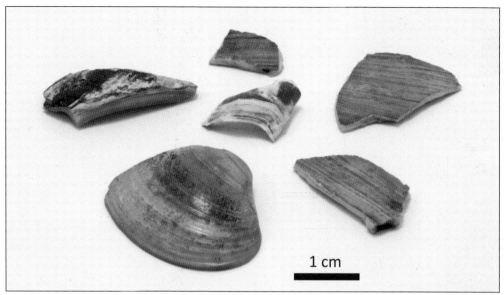

The fossil deposits at La Brea are relatively recent, dating back only as far as 50,000 years ago. The same faunal grouping is found elsewhere in the United States as early as 200,000 years. The sea covered much of the Los Angeles basin until the late Pleistocene, as evidenced by these marine shells that were recovered from drill cores from below the level of the fossils deposits. (Carrie Howard photograph.)

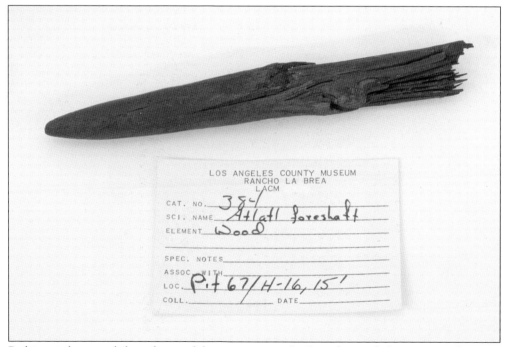

Prehistoric humans left evidence of their presence at La Brea, but no habitation sites have yet been discovered. This implies that the early occupants of the Los Angeles basin only visited the tar seeps, perhaps to collect asphalt to use to waterproof their canoes and baskets. This artifact, identified as an atlatl shaft, was found in Pit 67. (Carrie Howard photograph.)

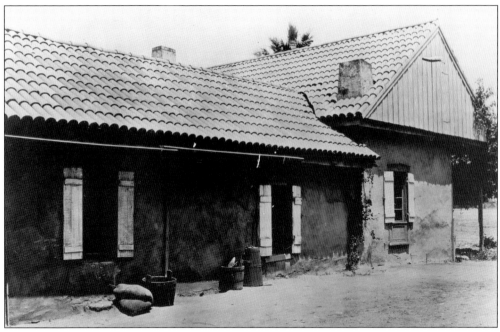

Antonio Rocha never lived at La Brea because it was farmland, far from the small town of Los Angeles. A portion of land was leased to, and later owned by, James Thompson, who built the first house on the rancho in 1852. Thompson eventually lost the land in a bankruptcy in 1880, and it was purchased by A.F. Gilmore and his partner, Julius Carter, for use as dairy. Gilmore acquired sole ownership of the land in 1890 and ran the dairy until approximately 1904. Oil was discovered in 1900, and Gilmore went into the oil business. His son E.B. Gilmore joined him in 1913, and their company eventually became the largest independent oil company in the West. The Gilmore adobe is shown above in the early 1900s and below in the 1970s. (Above, Seaver Center; below, A.F. Gilmore Company.)

Henry Hancock was a native of Bath, New Hampshire, and as a young man served in the US war with Mexico, rising to the rank of major. He arrived in San Francisco in 1849, lured by stories of the discovery of gold in California. Soon he was drawn to the southern part of the state where he worked as a surveyor, practiced law, and served in the state assembly. (NHM, Museum Archives.)

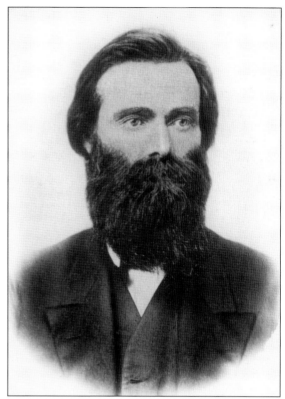

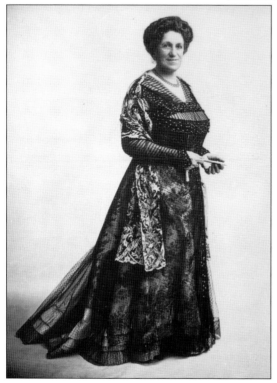

This photograph shows Madame Ida Hancock around 1900. Ida was the daughter of the Hungarian nobleman Count Agostin Haraszthy, who was a pioneering California vintner. She was educated in Europe and, upon her return, married Maj. Henry Hancock, who was 20 years her senior. The marriage took place in San Francisco in 1863, and afterwards, the couple settled in Los Angeles. (NHM, Museum Archives.)

Henry Hancock built a simple ranch house on his La Brea property, directly north of the large commercial asphalt mine that he operated. He sold the tar, also know by the Spanish word *brea*, for fuel, paving material, and roofing. Hancock believed that the brea would eventually be immensely valuable but did not live to see the creation of the oil industry. (NHM, Museum Archives.)

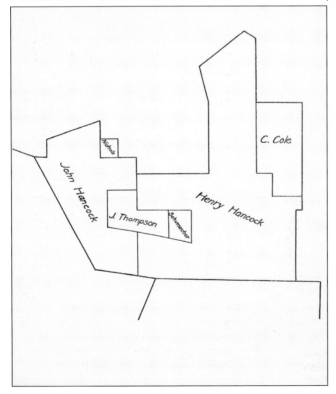

This map is from Clarice G. Bennett's 1938 thesis titled "A History of Rancho La Brea to 1900." Based on the county recorder's deeds, it shows the partition of Rancho La Brea in 1877 after the Rochas sold the property. Henry Hancock owned the largest portion of the rancho, and the southern boundary of his property is now Wilshire Boulevard. (NHM, Museum Archives.)

Henry and Madame Ida Hancock had two sons. George Allan (left) was born in 1875 and Bertram in 1877. The family divided its time between a cottage at the beach and the house at Rancho La Brea until 1883, when Henry Hancock fell ill and died. After returning from a visit to the Chicago World's Fair, Bertram Hancock developed typhoid fever and died at age 15. (Seaver Center.)

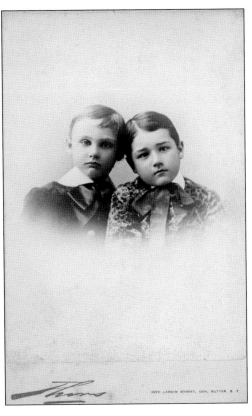

This *carte de visite* shows George Allan Hancock at age 18. The date, March 26, 1893, is written on the back. He was already assisting his mother in managing the ranch and brea mining operations at Rancho La Brea and was studying bookkeeping and accounting. Hancock's lifelong talent for invention and passion for music were already well developed by the time this photograph was taken. (Seaver Center.)

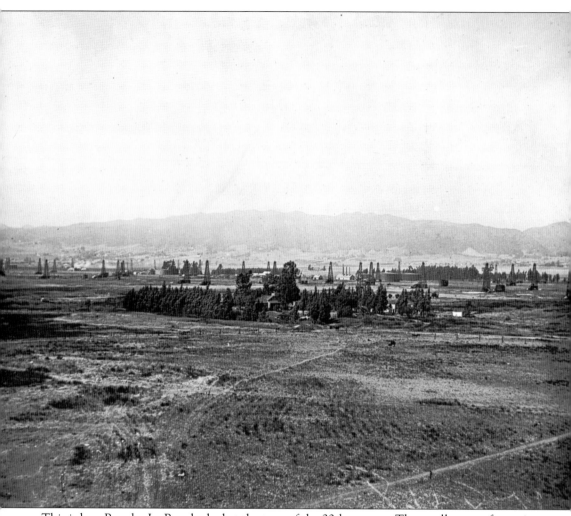

This is how Rancho La Brea looked at the turn of the 20th century. The small grove of trees in the center of the photograph surrounds the old Hancock ranch house and the asphalt mine. The Santa Monica Mountains are visible in the background, and oil derricks are beginning to dot the landscape. (Page Museum Archives, J.Z. Gilbert Collection.)

Two

INTO THE 20TH CENTURY
OILS WELLS AND FOSSIL DISCOVERIES

This c. 1907 photograph shows a typical tar volcano with a quarter placed on top of it for scale. The asphalt seeps often formed raised mounds that indicated where fossil deposits might be found. The pits of liquid asphalt now seen at La Brea are actually the depressions left by early excavations that have filled up with tar. (Page Museum Archives, J.Z. Gilbert Collection.)

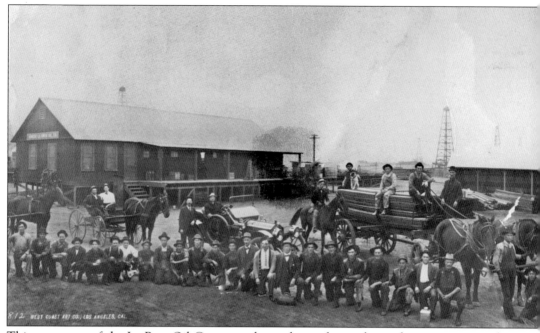

This panorama of the La Brea Oil Company shows the workmen, horse-drawn wagons, and drilling equipment posed in front of the company's facilities with some of the company's wells in

In 1885, Madame Ida Hancock entered into her first lease for oil drilling on Rancho La Brea, and though the endeavor was only moderately successful, this was the beginning of the Union Oil Company. Fifteen years later, her second oil lease was more successful. George Allan Hancock began his own oil company and drilled his first oil-producing well in February 1907. (NHM, Museum Archives.)

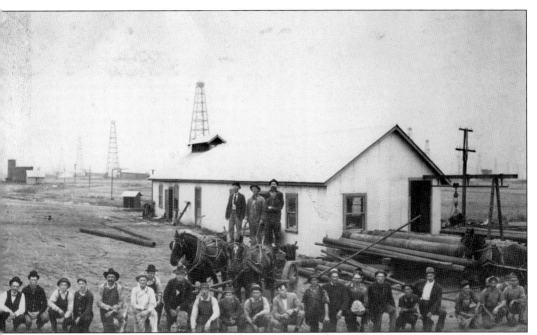

the background. George Allan Hancock is the well-dressed man in the hat seated in the open vehicle at the left. (Seaver Center.)

This image from a stereograph shows George Allan Hancock at one of his wells. Hancock was a talented inventor, and he worked for the Salt Lake Oil Company for several years and learned the mechanics of drilling for oil through hard work and study. He personally oversaw the production of his oil company and drilled a total of 71 wells. (Page Museum Archives.)

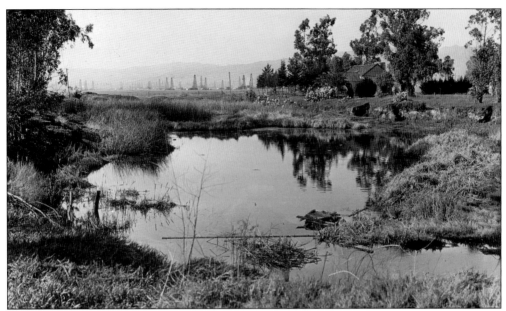

The old ranch house at La Brea is viewed from the south around 1912. With the discovery of oil and the wealth that it brought, George Allan Hancock and his mother, Ida, moved to more elegant accommodations, and the ranch house was abandoned. Although there had been several fossil excavations by this time, the major digs were yet to come. (Page Museum Archives.)

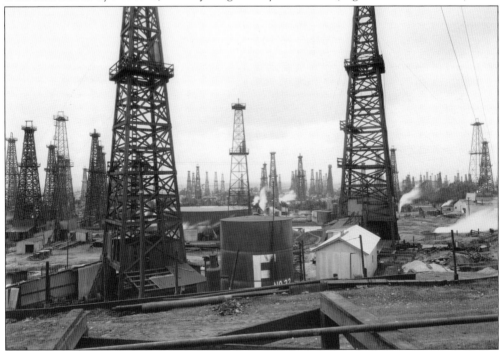

At the height of the oil boom, there was a "forest of oil wells" north of the Hancock's ranch house. This photograph shows the density of the wells in Los Angeles during the early years of the 20th century; there were hundreds of derricks in the relatively small area between the La Brea tar pits and Hollywood. (Seaver Center.)

William Denton, a noted geologist and spiritualist, was the first person to recognize that the bones from the asphalt beds of Rancho La Brea were those of long extinct animals. His 1875 paper on the fossils, published in the *Proceedings of the Boston Society of Natural History*, went largely unnoticed. It would be another 26 years before the fossils once again were the focus of scientific attention. (Wellesley Historical Society.)

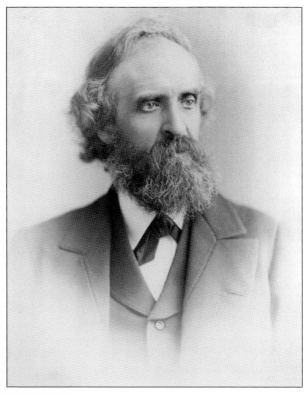

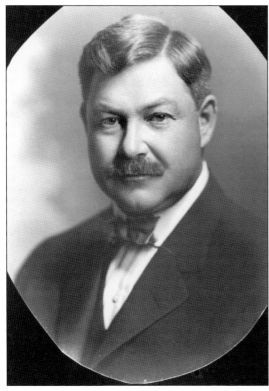

In 1901, the geologist W.W. Orcutt recognized that the bones uncovered by the oil operations at La Brea were not from domesticated animals but were instead the remains of prehistoric animals. He approached his alma mater Stanford, wanting them to excavate the site. Stanford declined to do so and referred Orcutt to J.C. Merriam at the University of California. (Santa Paula Historical Society.)

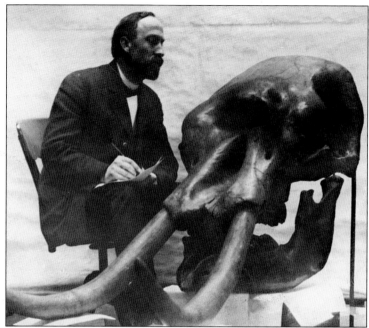

At the beginning of the 20th century, John C. Merriam was one of the country's most famous paleontologists and a professor at the University of California, Berkeley. In 1906, he mounted the first excavations at La Brea, which the university continued periodically until 1913. He is seen here posing with a Columbian mammoth skull with initial restoration of the tusks. (Page Museum Archives, J.Z. Gilbert Collection.)

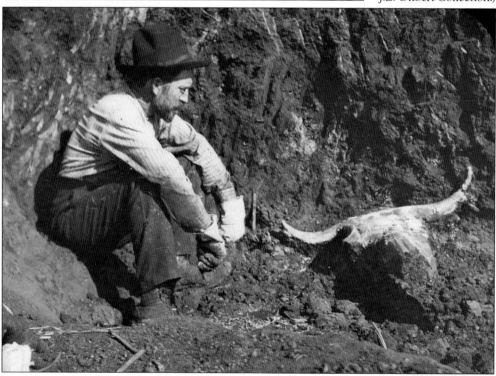

James Zacchaeus Gilbert was born in Indiana in 1866. He received degrees at McPherson College and then studied at the University of Kansas under paleontologist S.W. Williston. Gilbert came to California in 1904 and became a biology teacher at Los Angeles High School. Between 1907 and 1910, he supervised the Los Angeles High School's and the Southern California Academy's excavations at La Brea. (Page Museum Archives, J.Z. Gilbert Collection.)

After J.C. Merriam visited La Brea and confirmed that the site held significant fossil deposits, the University of California, Berkeley was the first institution granted permission by the Hancocks to excavate on the property. The digging commenced in 1906, and Merriam published the first article about the fossils in *Sunset* magazine in 1908. Titled "Death Trap of the Ages," this article made the La Brea tar pits world famous. Berkeley continued to dig sporadically and mounted a major excavation that lasted from August 1912 to April 1913. Merriam used his students as excavators, and graduate student R.C. Stoner supervised the 1912–1913 dig. Chester Stock, who later would become famous for his work on the fossils of La Brea, was an undergraduate member of this excavation. (Both, Page Museum Archives.)

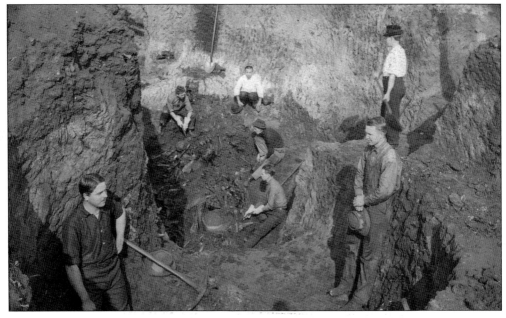

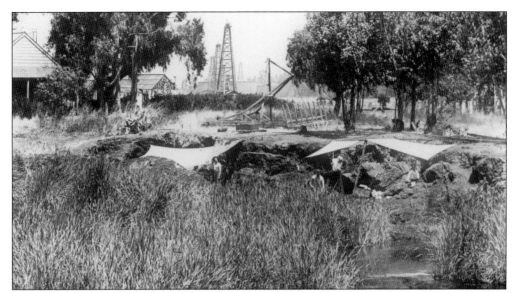

The Hancocks granted permission to several other institutions to excavate at La Brea in the early years of the 20th century, including Los Angeles High School and the Southern California Academy of Sciences. This photograph, taken by George Dorsey, who was one of the student excavators, shows the Los Angeles High School's dig, with the old ranch house and the oil field in the background. (Page Museum Archives, Bonnie Dorsey Shinski Collection.)

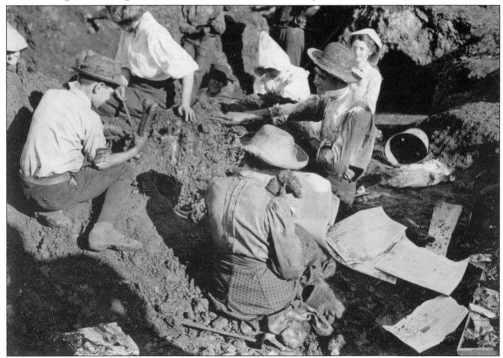

J.Z. Gilbert's students were diligent excavators, and the fossils they collected were studied for many years at the high school. By today's standards, the students would be overdressed, and it is hard to imagine sitting in the sun digging for fossils wearing shirtwaists and long skirts. (Page Museum Archives, John M. Phillips Collection.)

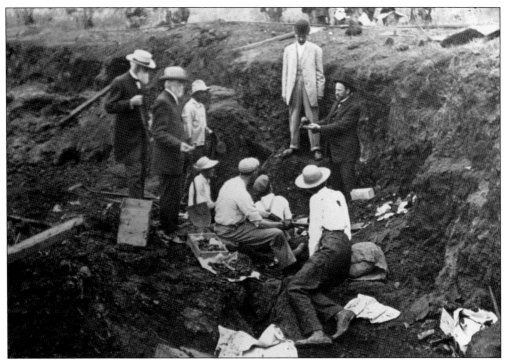

By the time the Los Angeles High School's and the Southern California Academy's excavations were in progress, the tar pits had become famous and started to attract visitors. This image, taken from a lantern slide, shows J.Z. Gilbert giving a tour of the excavation site to some obviously well-to-do sightseers, with the student excavators looking on. (Page Museum Archives, J.Z. Gilbert Collection.)

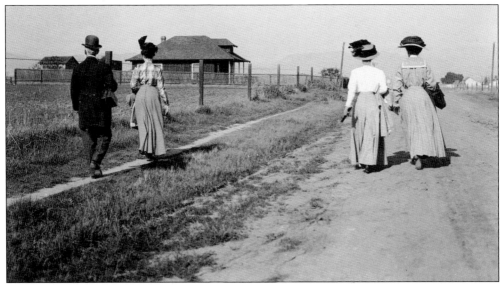

The Hancock property at Rancho La Brea was still very rural and a long way from the city of Los Angeles when this photograph was taken in 1908. These nicely dressed individuals are walking down Wilshire Boulevard on either their way to or from a visit to the fossil excavation. (Page Museum Archives, John M. Phillips Collection.)

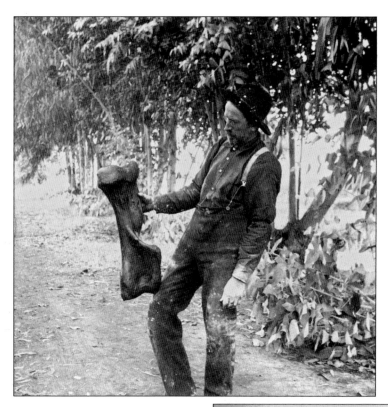

This image from a stereopticon card shows J.Z. Gilbert holding a mastodon's right humerus, or upper front-leg bone. He is wearing his digging clothes, so one can assume this was taken at La Brea. Considering the weight of this bone, it is unlikely that he held the pose for long. The excavations by Los Angeles High School and Southern California Academy collected bones from at least four mastodons. (Page Museum Archives.)

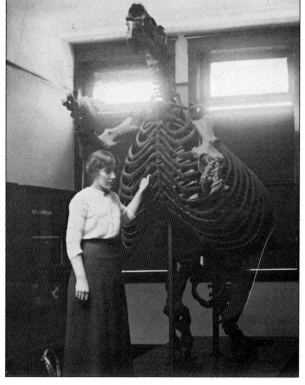

One of the more impressive specimens in the Los Angeles High School collection was this mounted ground sloth skeleton, which for many years was exhibited in the school museum. Here, a student stands next to the sloth, and it towers over her, illustrating how large these animals must have been. (NHM, Museum Archives.)

This is another photograph by George Dorsey; it comes from an extraordinary scrapbook of pictures that he took while he was a student of J.Z. Gilbert. Dorsey's daughter Bonnie Shinski allowed the Page Museum to copy the photographs, and they have greatly added to the understanding of these early excavations. Some of the specimens collected by the students are displayed in this picture. (Page Museum Archives, Bonnie Dorsey Shinski Collection.)

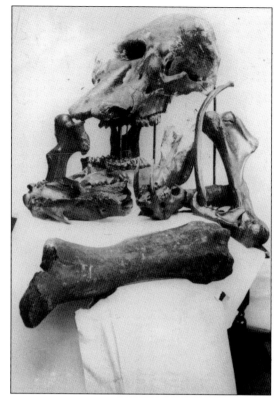

Gilbert's fossil museum at the high school was used for generations to teach students about science. Vera Von Block (right) and her friends in the Curators Club pose here with a mounted sloth skeleton. Gifted students were recommended for the Los Angeles County Museum's natural science program, and Vera specialized in paleontology at the museum. She later married David Packard, another graduate of the high school and the museum programs. (David Packard.)

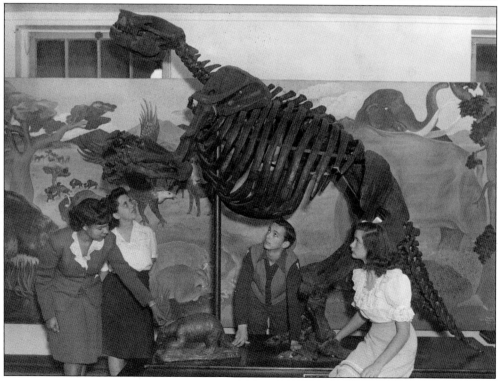

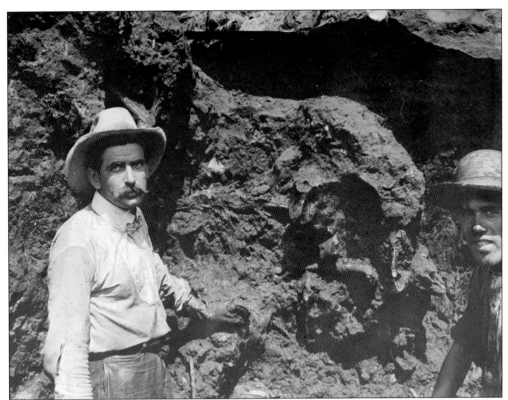

J.Z. Gilbert also supervised the Southern California Academy of Sciences's excavations at La Brea, and the fossils that the academy collected became some of the first exhibits in the new Los Angeles County Museum of History, Science, and Art. In this image, reproduced from a lantern slide, two excavators pose in front of a fossil deposit. (Page Museum Archives.)

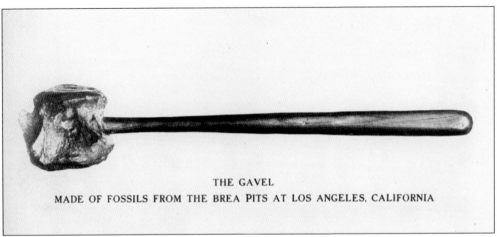

THE GAVEL

MADE OF FOSSILS FROM THE BREA PITS AT LOS ANGELES, CALIFORNIA

This gavel, made from a caudal vertebra of a ground sloth and wood from the Pit 3 tree, was presented to the Southern California Academy of Sciences by Los Angeles naturalist Anstruther Davidson at its annual meeting on October 17, 1914. It was his intent that this one-of-a-kind gavel would inspire further scientific research. (NHM, Museum Archives.)

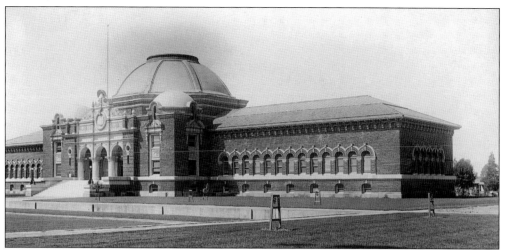

The Los Angeles County Museum of History, Science, and Art opened in 1913 in conjunction with the opening of the Los Angeles Aqueduct that brought water to the city. The Southern California Academy of Sciences was one of the museum's founders, and its collection of La Brea fossils was among the first exhibits. Hancock granted the museum the exclusive right to dig at La Brea in 1913. (NHM, Museum Archives.)

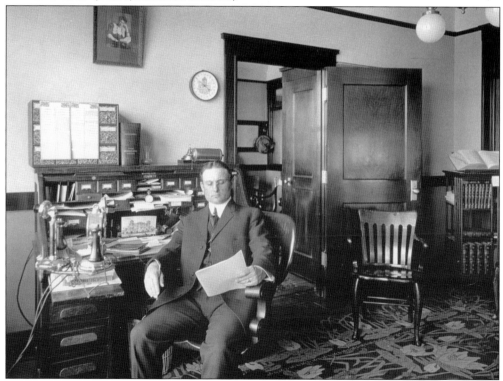

George Allan Hancock is shown in his office around the time the museum opened. By 1913, he was a very successful businessman, but he still retained his fascination for the fossil site and wanted La Brea to be preserved as a scientific monument. He was concerned that too many groups were digging at the tar pits, so the new museum became the solution to the problem. (NHM, Museum Archives.)

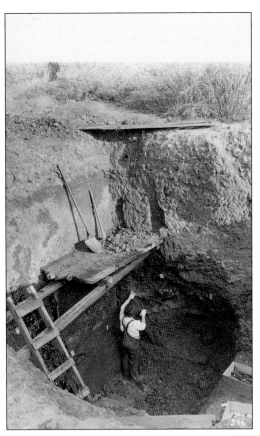

In Pit 60, as in all of the fossil deposits dug in the 1913–1915 excavations, the measures taken to prevent the workmen from being injured were decidedly primitive. This excavator works under a platform that serves both as a means of getting down to the level of the deposit and also as a shelf to catch the asphaltic matrix that falls off the excavation walls. (Page Museum Archives.)

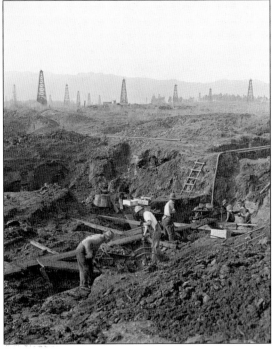

Pits were numbered sequentially, and the digging sites were chosen where active seeps were evident. After the preliminary work in Pit 61, the excavations continued, and other sites were explored. Pit 67, shown here, turned out to be one of the largest and richest deposits, and it soon became obvious that Pit 67 and Pit 61 were actually two ends of the same fossil deposit. (Page Museum Archives.)

Most of the "elephant" bones found during the early La Brea excavations came from Pit 9 and consisted of individuals of two species—the Columbian mammoth and the American mastodon. The preservation in Pit 9 was unusually bad, and it is thought that water from a natural spring associated with the asphalt seep at this location caused the bones to deteriorate. (Page Museum Archives.)

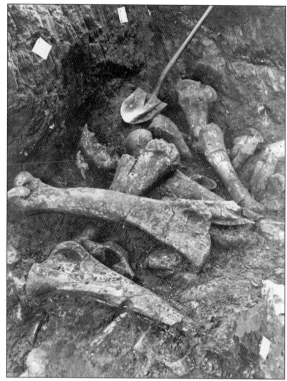

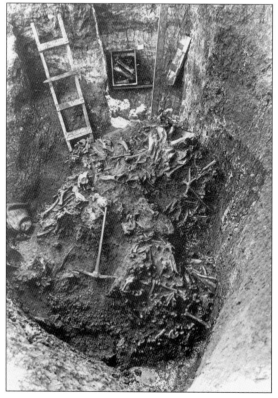

The excavation of Pit 91 began on June 13, 1915, and bones were discovered 10 feet below the surface. The pit was never completely excavated, and the intention was to leave it open as an exhibit. The planned roof and support timbers were never installed, and the pit caved in, burying the remaining bone mass. Exactly 44 years later, Pit 91 was reopened, yielding thousands of new fossils. (Page Museum Archives.)

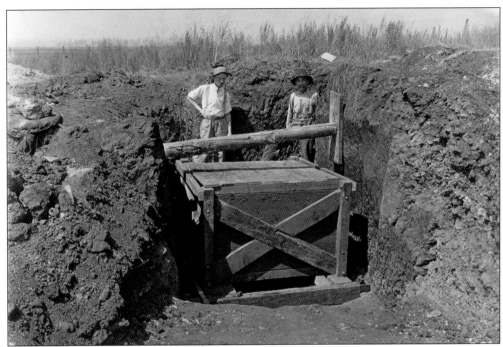

In 1915, the museum excavators discovered a fossil deposit that was small enough to be removed intact, and the intent was to use it in an exhibit that would show how a typical fossil bed was situated in the ground. Removing the block from Pit 81 presented some challenges, since the entire deposit weighed about four tons. The excavators cut around the deposit and then built a wooden box around it while the fossils were still in the ground. The photograph above is of the completed box in the ground, and the one below shows the box being hoisted up to a waiting wagon. It was then transported to the Los Angeles County Museum. (Both, Page Museum Archives.)

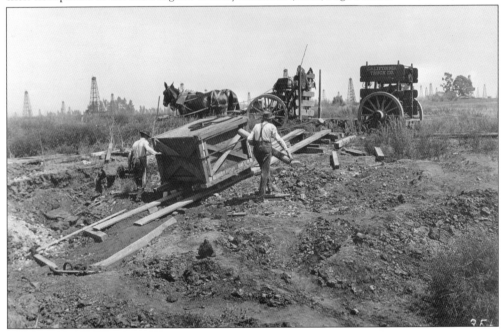

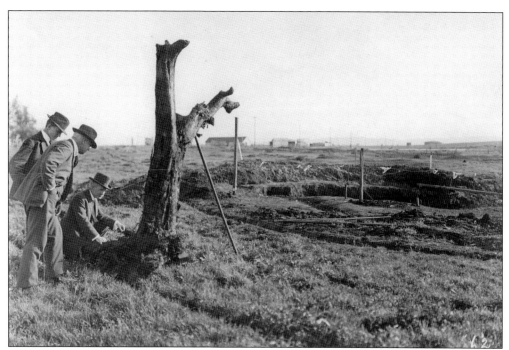

In 1914, an entire tree was discovered upright in the Pit 3 excavation. The tree was originally identified as a McNab's cypress but is now known to be a juniper. The Pit 3 tree was on exhibit in front of the Charles Knight mural in the Hancock Hall for many years and is now part of a new exhibit at the George C. Page Museum. (Page Museum Archives.)

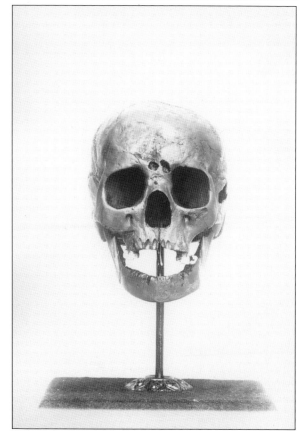

Only one human's remains were found in the tar pits. In 1914, a skull and 12 bones of La Brea Woman were discovered in Pit 10, along with a few artifacts and the partial skeleton of a domesticated dog. Carbon dating has determined that she lived 10,000 years ago. The dates for the fossil deposits are from 40,000 to 10,000 years ago. (Page Museum Archives.)

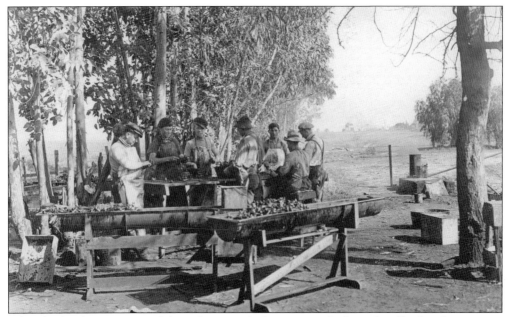

After the fossils were removed from the ground, they were soaked in tubs of boiling kerosene to dissolve the tar and loosen the sediment that remained on the bones. The excavation crew then scrubbed off any remaining dirt and packed the bones in wooden boxes so that they could be transported to the museum for identification and numbering. (Page Museum Archives.)

Paleontologist John C. Merriam (left) and museum director Frank S. Daggett are seen here standing in front of the barn at La Brea in March 1914. The boxes used to store the fossils can be seen behind them. Merriam organized the University of California's excavations at La Brea, which had ended in 1913 when the museum was given the exclusive right to dig at the site. (Page Museum Archive.)

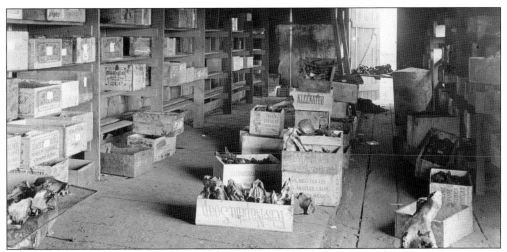

After the fossils were dug up, cleaned, and boxed, they were stored in the barn adjacent to the old ranch house until they could be transported to the museum. Used wooden packing boxes, such as those for Fels Naptha soap and other household products, were ideal for storing the fossils. This image shows the interior of the barn and boxes packed with fossils. (NHM, Museum Archives.)

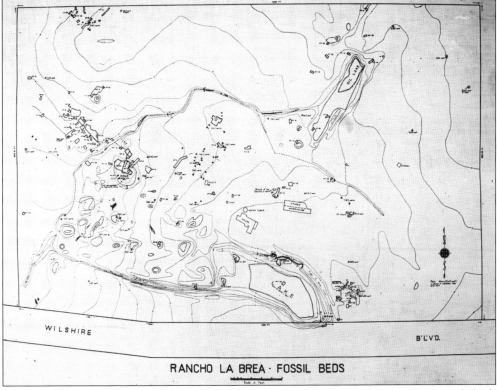

RANCHO LA BREA · FOSSIL BEDS

During the Los Angeles County Museum's 1913–1915 excavations, workers dug 96 pits, of which about a third yielded significant quantities of fossils. By the time that the excavations were over, hundreds of thousands of bones had been removed from the ground and added to the museum's collections. This detailed map shows the location of the museum's pits and the other features of the property. (Page Museum Archives.)

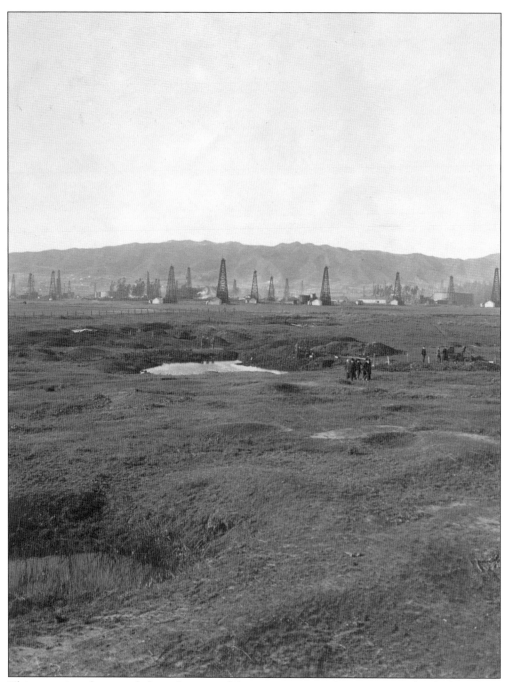

This stunning photograph from the time of the county museum's excavations clearly shows how rural La Brea still was in the early years of the 20th century. A large area of agricultural land is bordered on the north by the oil fields, and the Santa Monica Mountains are clearly visible in the background. The photograph is undated but was taken at some point during the museum's dig, and the figures appear to be those of the workmen and several well-dressed visitors. By this time, the site had become famous and attracted many tourists and was, in spite of its relative remoteness, a must-see destination for visitors to Los Angeles. (Page Museum Archives.)

Three

A City Comes of Age
A Museum for Los Angeles

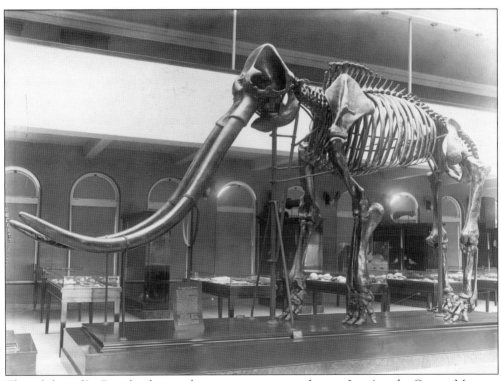

The exhibits of La Brea fossils were the major attraction at the new Los Angeles County Museum of History, Science, and Art, and this is how the La Brea Hall looked in 1919. The mammoth is sporting a long set of tusks that were later found to be inaccurately restored and were subsequently replaced. All of the fossils originally displayed in the museum came from the Southern California Academy's excavations. (NHM, Museum Archives.)

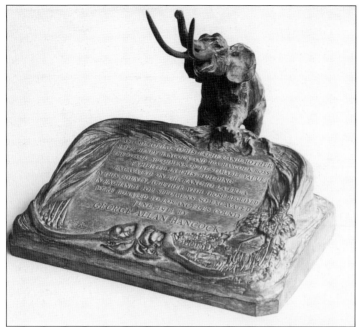

The Hancock Memorial Tablet was designed by sculptor Carlo Romanelli and is a memorial to George Allan Hancock's parents, Henry and Ida. Part of Hancock's agreement with the county was that the fossils were to be retained by the museum and forever be known as "the Hancock Collection." This tablet must be displayed with the fossils and is currently on exhibit in the George C. Page Museum. (Page Museum Archives.)

Almost immediately upon opening its doors, the new museum became a destination for visitors to Los Angeles who were anxious to see the famous fossils from the La Brea tar pits. Crown Prince Gustav Adolphus and Princess Louise of Sweden toured both the excavation site and the museum in 1926 and are shown here posing under the Columbian mammoth skeleton in the La Brea Hall. (NHM Archive.)

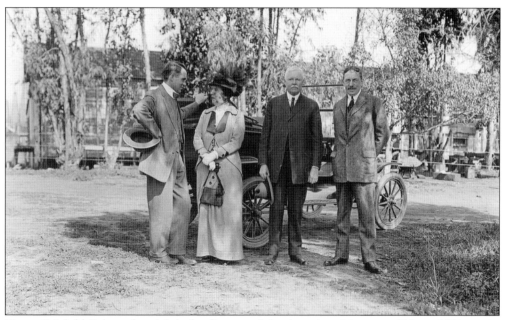

Henry Fairfield Osborn (on right), the director of the American Museum of Natural History in New York, is seen here visiting Rancho La Brea with his wife, Lucretia, and Los Angeles County Museum director Frank Daggett in February 1914. The man on the left, chatting with Mrs. Osborn, is Loye Miller, a professor at the Los Angeles Normal School (later UCLA) and a specialist in fossil birds. (Page Museum Archives.)

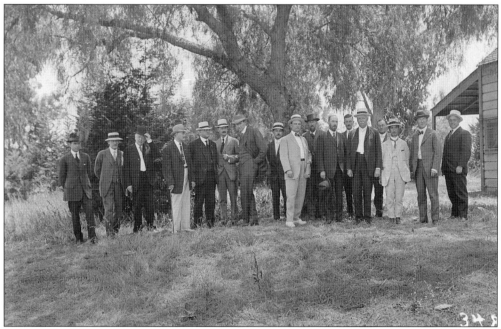

The American Association for the Advancement of Science held its annual meetings in Los Angeles in 1915, and the members took a field trip to La Brea on August 13. The dapper gentleman in the light suit, bow tie, and boater in the center of the photograph is G. Allan Hancock. (Page Museum Archives.)

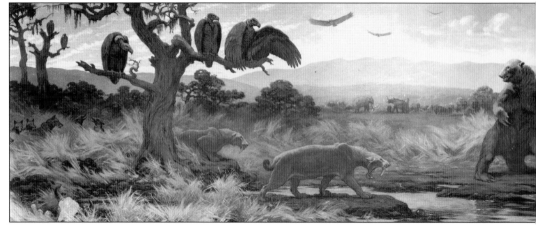

In 1925, the Los Angeles County Museum commissioned the famed New York artist Charles R. Knight to paint a mural that illustrated life at La Brea 40,000 years ago. The large painting was to be hung at the end of the Hancock Hall. Knight was the preeminent painter of prehistoric life of his day, and his murals graced the halls of the American Museum of Natural History in New York. The Knight mural was painted on canvas in two sections that were each 25 feet wide

This photograph shows Eugene Fischer working on the skeleton of the mammoth in the La Brea Hall at the Los Angeles County Museum. The first tusks have been replaced with correctly shaped ones, and he appears to be putting some finishing touches on the skull. In the early mounts, the bones were often covered with a layer of plaster to even out cracks and then painted "La Brea" brown. (NHM, Museum Archives.)

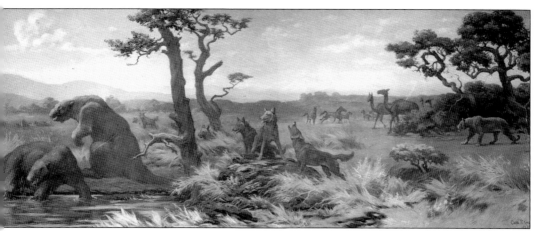

and 10 feet high. When installed in the Hancock Hall, the mural covered the entire back wall. Considered to be Knight's masterpiece, the famed painting, with its stalking saber-toothed cat, standing sloth, and teratorns in the dead tree became an iconic image of La Brea in its own right. (NHM, Museum Archives.)

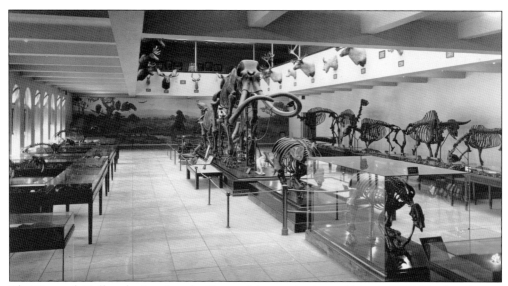

The Hancock Hall at the Los Angeles County Museum is pictured here in 1927. The first floor of the gallery displayed the fossils from the tar pits, including the mounted skeletons of the Columbian mammoth and the saber-toothed cat. Charles R. Knight's famous La Brea mural (seen above), painted in 1925 specifically for this gallery, is in the background. (NHM, Museum Archives.)

Henry Anson Wylde began his long career at the museum in 1924 as an assistant to the museum osteologist, J.W. Lytle. He worked for many years in paleontology, cataloging collections, excavating fossil sites, and creating mounted skeletons for exhibits. He is pictured with his mount of the baby mastodon from La Brea, and the image below is of a painting that Wylde created of the little mastodon's demise. Wylde was a talented artist as well as a scientist and became the first chief of the museum's exhibitions division in 1941. Wylde and Hildegarde Howard were assigned to clean up after a flood in the museum basement and they fell in love while wiping mold off of La Brea bones. They married in 1930. The marriage lasted 54 years, until Wylde's death in 1984. (NHM, Museum Archives.)

Hildegarde Howard began her association with the museum in 1921 as student, and she first worked as an assistant to J.W. Lytle. She helped him sort and identify the vast number of saber-toothed cat bones from the tar pits, some of which Lytle used to make the first mounted skeleton of this extinct cat. Howard obtained her undergraduate and graduate degrees from the University of California, Berkeley, where she studied under paleontologist Chester Stock. Another one of her advisors, Dr. Loye Miller, kindled her interest in avian paleontology, and she did pioneering work on the many species of birds that were found in the La Brea tar pits. Her master's thesis was on the turkey from La Brea, and she is also known for her work on the giant teratorn. In 1953, she won the Brewster Medal from the American Ornithologists Union for her outstanding research in the field of avian paleontology. After Chester Stock's untimely death, Dr. Howard became chief curator of science in 1951, and she retired in 1961. (NHM, Museum Archives.)

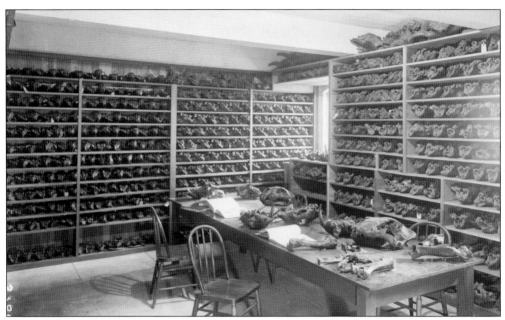

After the La Brea fossils were transported to the museum, they were numbered and cataloged and then stored in rooms in the basement. The skulls were stored together in one room on specially constructed shelves, where they could be readily available for research. These photographs of the skull room show hundreds of skulls of extinct animals entirely filling the shelves. In the photograph below, originally published in *Pictorial California* magazine in 1928, J.W. Lytle (right), holding the skull of an American lion, appears to be discussing it with museum director William A. Bryan. Directly in front of them on the table are two horse skulls, a horse jaw, a saber-toothed cat skull and jaw, and another lion skull. (Above, NHM, Museum Archives; below, Seaver Center.)

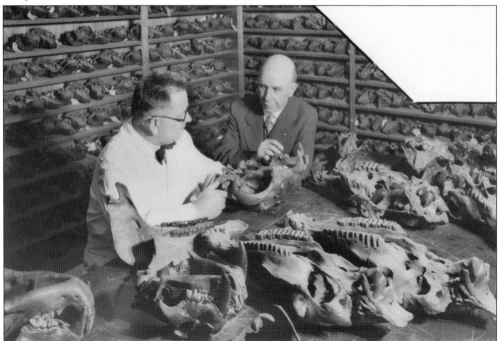

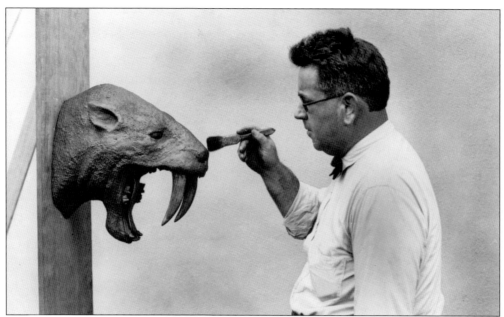

J.W. Lytle began working for the museum in 1913 at La Brea during the fossil excavations and continued working for the museum until his death in 1931. Lytle had little formal education; he had been a railroad man prior to his employment at the museum. But he was fascinated by science, read extensively, and educated himself in geology, paleontology, and anatomy. After the excavations were completed, Lytle supervised the identification and cataloging of the La Brea fossils and created several unique displays for the museum. In the photograph above, he is putting the finishing touches on a reconstruction of a saber-toothed cat's head, which still exists and is in the Page Museum lab. Below, Lytle is working in the "Bone Room" in the basement of the museum, sorting saber-toothed cat vertebrae. (Both, NHM, Museum Archives.)

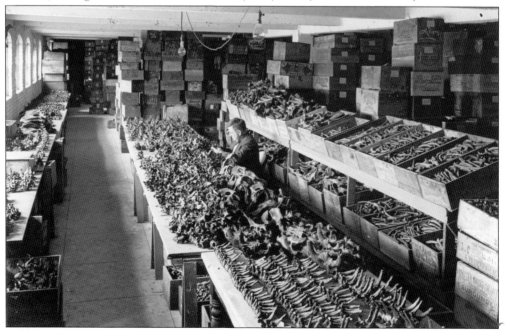

Roy Lee Moodie, known as the "Father of Paleopathology," studied the ancient injuries that are evident in prehistoric human and animal remains. He taught zoology at the University of Kansas and anatomy at Baylor University until advancing Parkinson's disease forced him into an early retirement. Moodie moved to California in 1928 and researched pathologies found in La Brea bones until his death in 1934. (University of Kansas Libraries, University Archives.)

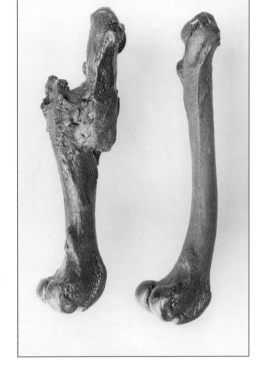

Moodie had photographs taken of the bones that interested him, and this one compares a pathologic dire wolf right femur with a normal one. The bone on the left suffered a compound fracture that had healed but probably left the animal crippled and in pain. The dire wolf did not die of the injury and lived long enough for the excess bone growth to form. (Page Museum Archives.)

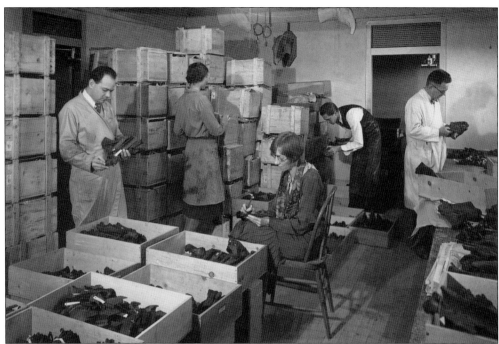

Some of the La Brea bones were sent to other museums in exchange for fossils from different sites, which helped the Los Angeles County Museum build its paleontology collections. This photograph, taken in 1931, shows J.W. Lytle and his crew sorting and boxing bones to be exchanged. Lytle is on the right, and the man in the back is Henry Wylde. (NHM, Museum Archives.)

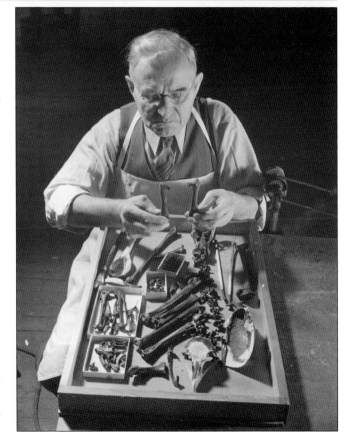

Bird bones are extremely delicate and brittle and are difficult to mount into skeletons. In spite of the problems presented by the bird bones, Eugene Fischer was a master craftsman, and his mounts of the La Brea birds were exceptional. He is seen here examining a pair of femurs to determine if they are a good match for a mount. (NHM, Museum Archives.)

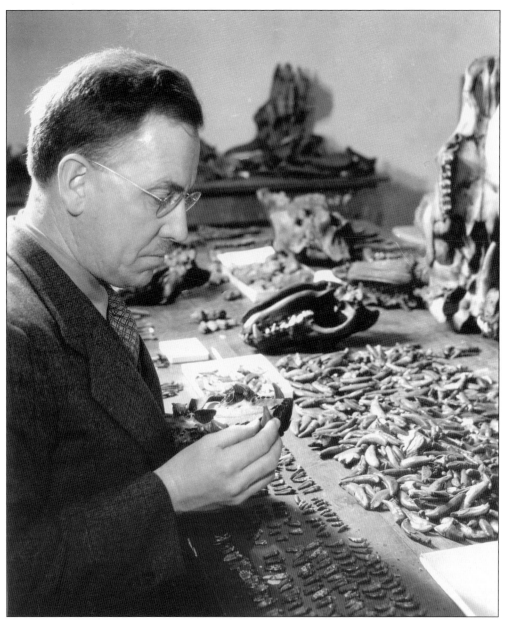

Chester Stock was born in 1892 to immigrant parents in San Francisco, where he survived the Great Earthquake of 1906. He left school to help support his family but fell ill from hard labor, and his mother and brother sent him back to school. He entered the University of California in 1913 intending to study medicine but was encouraged by John C. Merriam to study paleontology instead. Stock obtained his bachelor's, master's, and doctoral degrees from Berkeley and went on to become one of the most respected mammalian paleontologists of the 20th century. He is known for his work on La Brea fossils, and he first became associated with the site as an undergraduate during the Berkeley digs. In 1926, Stock became a professor at the California Institute of Technology in Pasadena, and he also served as part-time curator of paleontology at the Los Angeles County Museum. In 1948, he was appointed chief curator of science and was actively involved with the plans to renovate Hancock Park at the time of his death in 1950. (NHM, Museum Archives.)

Four

HANCOCK PARK
CREATING A LANDMARK

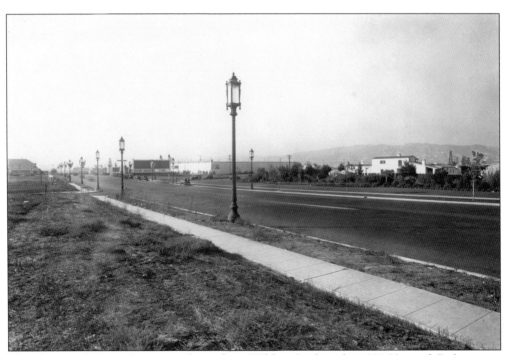

This photograph shows the westward view down Wilshire Boulevard in 1929. Hancock Park is across the street, and the large building used for the museum director's residence is visible in the background. The area was just beginning to be subdivided, and the streetlamps look out of place in what is then still a rural area outside the city limits of Los Angeles. (NHM, Museum Archives.)

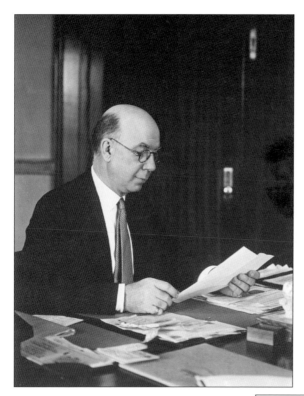

From 1921 to 1939, William Alanson Bryan served as the second director of the Los Angeles County Museum. He oversaw the great expansion of the museum's buildings, programs, and staff in the 1920s and the difficulties presented to the institution by the Great Depression of the 1930s. Bryan was an ornithologist and, before coming to the museum, was a curator at the Bishop Museum in Hawaii. (NHM, Museum Archives.)

One of Dr. Bryan's ideas for landscaping Hancock Park was to have the outer edge framed with a border of hibiscus plants imported from Hawaii. This was to be the largest hibiscus garden outside of Hawaii and to extend for almost a mile. No evidence exists that any of the plants ever made it to Hancock Park because the imported tropical hibiscus cuttings froze before they could be planted. (Seaver Center.)

Another feature of Bryan's plan for Hancock Park was a decorative bridge that was to span the Lake Pit and serve as the main entry to the park. Shown here, the model for the bridge is complete with elaborate sculptures supported by pedestals in the shapes of horse legs. The bridge was apparently a casualty of the Great Depression and was never built. (NHM, Museum Archives.)

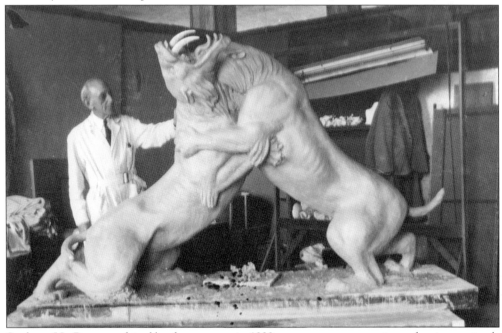

Sculptor J.L. Roop was hired by the museum in 1929 to create reconstructions of extinct animals from the tar pits for Hancock Park. Roop was well suited for the job, as he had already sculpted dinosaurs for the silent movie *The Lost World*. He is shown here with his magnificent fighting saber-toothed cats before the sculpture was installed in the park. (NHM, Museum Archives.)

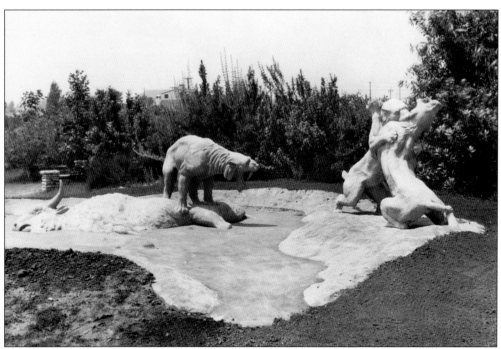

J.L. Roop's fighting saber-toothed cats were placed in the park next to his sculpture of a snarling cat standing on the body of a bison trapped in a tar seep. The scene was designed to show the viewer the drama that unfolded at La Brea during the Ice Age and was to be the first of many such sculptures. The idea of creating a "Pleistocene Zoo" of statues and a Pleistocene landscape in Hancock Park originated with G. Allan Hancock. Roop's dynamic sculptures could not erase the fact that the park was increasingly being surrounded by the city, as evidenced by the Goodyear Blimp in the background of the photograph below. The fighting saber-toothed cats have survived and are now installed in front of the Page Museum, but the bison and snarling cat disappeared long ago. (Both, Page Museum Archives.)

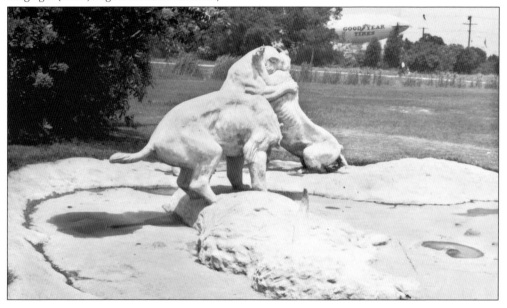

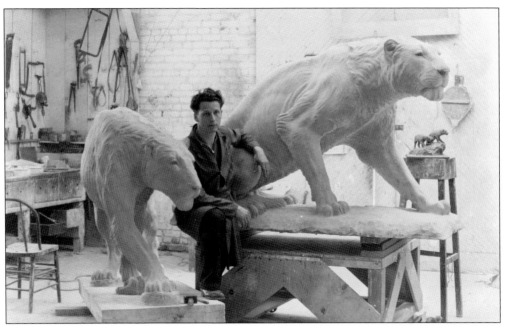

After the death of J.L. Roop, the museum's taxidermist Herman Beck was assigned to finish the animal sculptures for Hancock Park. He is shown here in the museum's old taxidermy building with the two statues of the American lion. The taxidermy building was located on the south side of the University of Southern California campus and was demolished in the 1980s to make way for a new dormitory. (NHM, Museum Archives.)

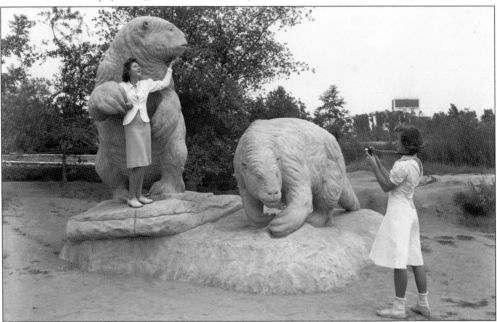

Museum student-worker June Ferguson strikes a pose with one of Herman Beck's sloth sculptures in Hancock Park, while her coworker Doris Randall takes her picture. Beck's Pleistocene statuary almost seemed to encourage this type of activity, and there are numerous photographs of tourists riding the American lions or climbing on the sloths. (NHM, Museum Archives.)

The landscaping of Hancock Park in the 1930s enclosed the tar pits with low stone walls to keep visitors from literally getting stuck in the tar. "Tar pit" is a misnomer, however, as the substance is liquid asphalt, and the asphalt-filled depressions in the park are actually the old excavation sites and are not naturally occurring pools of asphalt. (NHM, Museum Archives.)

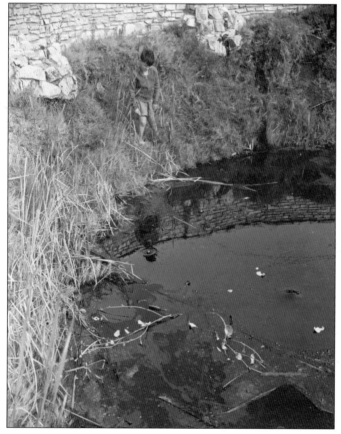

The low walls were obviously not adequate barriers and did not keep people from getting into the tar pits. Here, a child has climbed over the wall and is inspecting the viscous black liquid—and risking falling in and getting stuck. There are several newspaper accounts of people being rescued from the La Brea tar pits. (NHM, Museum Archives.)

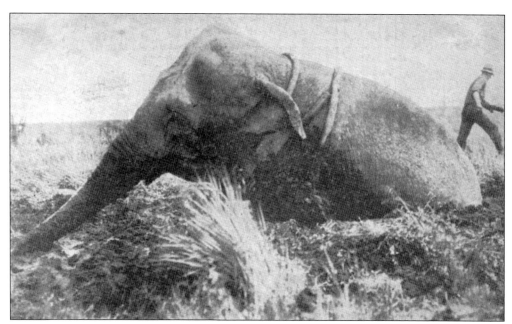

On April 8, 1935, elephants Tommy and Freda escaped from the Al G. Barnes Circus and got stuck in mud and tar in a vacant lot at the corner of Wilshire Boulevard and Fairfax Avenue. Heavy rains created the bog that trapped the lost pachyderms about 100 yards from Hancock Park. Tommy and Freda trumpeted loudly while startled motorists drove by. The circus used its other elephants to extricate the pair. (David Packard scrapbook.)

This is one of many examples of the low stone walls not being effective at keeping people out of the tar pits. R.B. Spowers had been feeling dizzy and lay down on one of the walls and somehow rolled into Pit 4. He was trapped by the asphalt's viselike grip and could not escape but was rescued by the park caretaker and taken to Hollywood Receiving Hospital. (Page Museum Archives.)

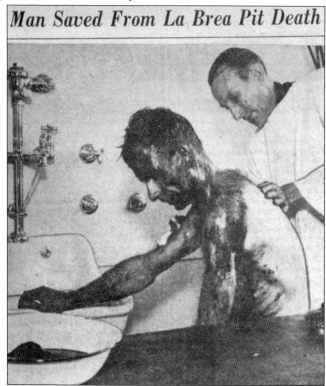

Man Saved From La Brea Pit Death

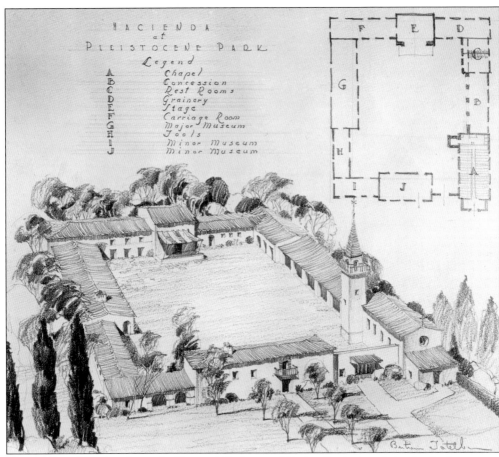

One feature of the first design for Hancock Park was a Mission Revival–style hacienda that was to have rooms opening onto an enclosed courtyard and feature exhibits of fossils from the tar pits. The building was also supposed to be a neighborhood meeting place. (NHM, Museum Archives.)

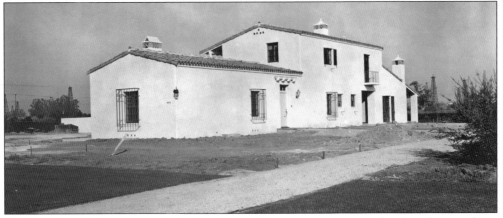

The large hacienda was never built, but this smaller structure was completed, and it may have been a section of the original design. There is no record of it ever being used as a community center or a museum. Instead, the building served as the museum director William Alanson Bryan's residence. (NHM, Museum Archives.)

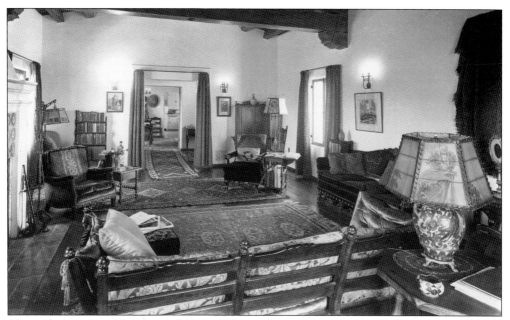

This is the interior of the Hancock Park residence when museum director William Alanson Bryan lived there. The architecture and the furnishings are typical of the type of Mission Revival houses that were popular in Southern California in the 1930s. Bryan was the only director to live in the house, which was later used as the residence for the park caretaker. (NHM, Museum Archives.)

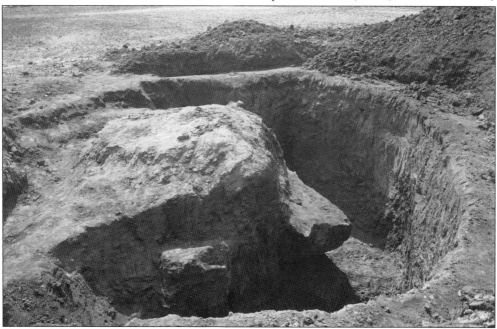

By the 1920s, paleontologists were aware that the information that could be learned from the early excavations was limited because only the larger bones had been collected, while those of the small animals were ignored. From 1926 to 1929, the museum excavated again and this time attempted to collect everything, including the birds, rodents, insects, and shells. Four seeps were excavated, and three yielded fossils. (NHM, Museum Archives.)

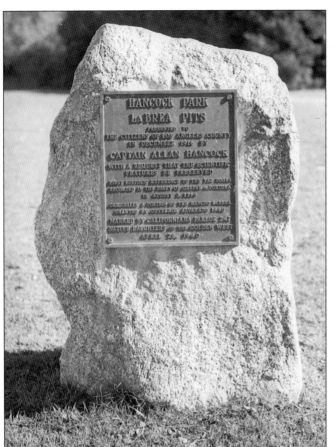

The California Parlor No. 247 of the Native Daughters of the Golden West placed this plaque in Hancock Park on April 28, 1940, to commemorate George Allan Hancock's gift of the land to the citizens of Los Angeles County. The plaque dates the gift to 1916, but in reality, the deed was not finalized until 1924. (NHM, Museum Archives.)

There were several plans to update Hancock Park using Works Progress Administration (WPA) money to build new facilities, including a museum to house some of the fossils on the site where they had been discovered. The outbreak of World War II ended the project. The proposed museum, shown in this 1941 rendering, was never built. (NHM, Museum Archives.)

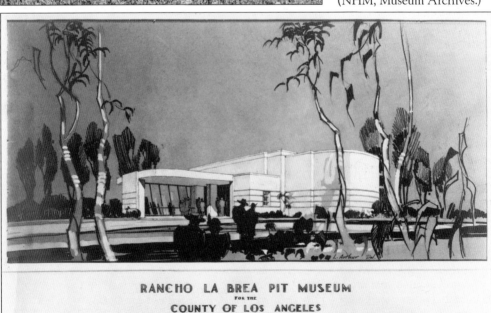

RANCHO LA BREA PIT MUSEUM
FOR THE
COUNTY OF LOS ANGELES
Samuel E. Lunden, Architect

Five

AFTER THE WAR
A NEW MONUMENT TO THE ICE AGE

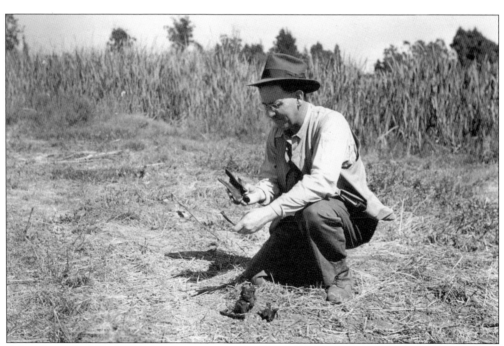

After the end of World War II, plans to renovate Hancock Park were revitalized. Chester Stock, in his roll of curator at the Los Angeles County Museum, was responsible for determining the features of the new plans, and one idea was to have a building designed to display a fossil deposit in situ. This photograph shows Stock examining a new find in Hancock Park. (Page Museum Archives, Richard Pierce Collection.)

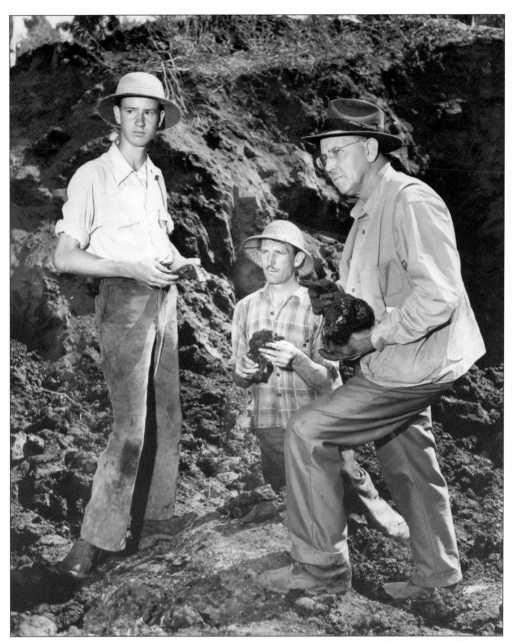

David Packard was a high school student in the Museum Junior Program when *Los Angeles Times* photographer R.O. Ritchie enlisted him to pose for this picture. Packard, on the left, is shown with Chester Stock, right, and park caretaker James Shelton. They are holding newly discovered fossils while standing in an excavation site in Hancock Park. The Junior Museum Program included a series of natural science courses for academically promising students, who were assigned to work directly with the museum's curators for a unique hands-on experience. Hundreds of students graduated from this special program, and many went on to careers in science. While a museum junior, Packard specialized in paleontology and ornithology, and he assisted Dr. Stock in his search for an appropriate fossil deposit for the new display pit building in Hancock Park. (David Packard, Phil Ritchie, R.O. Ritchie photograph.)

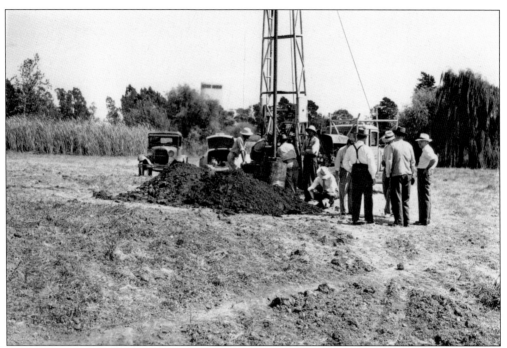

These photographs of Stock's Hancock Park drilling operation were taken in 1946 and belonged to donor Richard Pierce's mother. Stock's high school student-assistant David Packard is leaning on the drill rig in the above photograph. The drilling was intended to locate fossil deposits and also to gain information about the subsurface geology of the region. In an article printed in the *Los Angeles Times* on July 17, 1946, Stock states that they had drilled 87 test holes. One hole at the west end of the park yielded fossils at the depth of 15 feet, and another deposit was located just to the west of the old ranch house. (Both, Page Museum Archives, Richard Pierce Collection.)

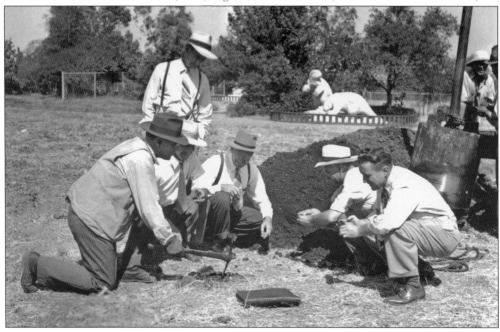

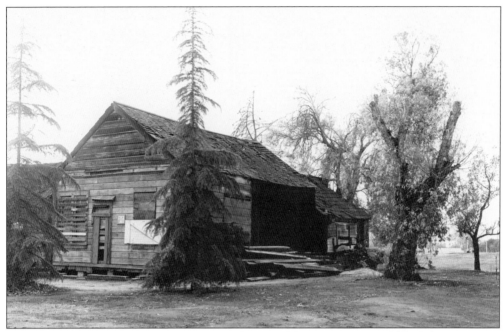

Although Hancock had originally intended that the old ranch house would be left intact as an exhibit of how La Brea was in the early years, by the 1940s the house had deteriorated to the point of being unsafe. The museum got permission from Hancock to tear down the building, and it is shown here shortly before its demolition in 1950. (NHM, Museum Archives.)

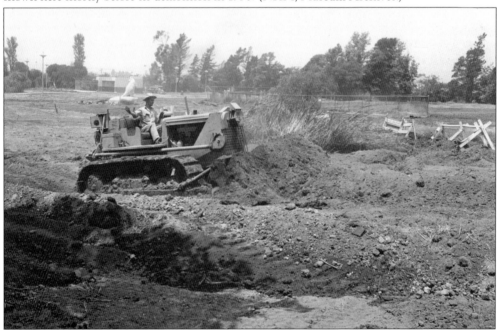

The master plan for Hancock Park was approved in 1948 and called for completely changing what was considered to be an overgrown eyesore into a modern city park. All new amenities, including new lighting, bathrooms, and walkways, were part of this renovation, as was a great deal of new grading. (NHM, Museum Archives.)

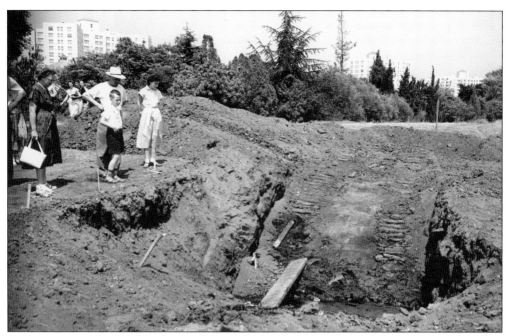

Construction in Hancock Park was always full of surprises. Broken water pipes, tar seeps, and a high water table were among the obstacles that had to be dealt with. This photograph, taken by the museum photographer in 1951, appears to be of a sinkhole. The Park La Brea apartments can be seen in the background. (NHM, Museum Archives.)

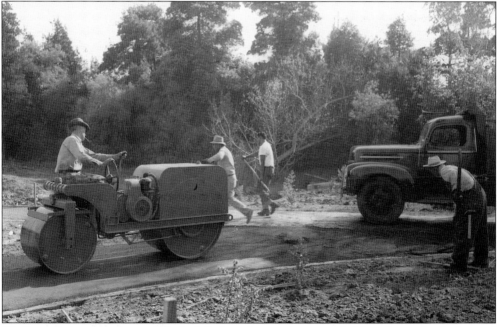

The extensive renovations to Hancock Park took several years to finish and completely changed the landscape of the park. New paths were installed that were designed to allow the visitors access to the important features, such as the old excavation sites and the new Observation Pit. Here, the workmen are grading the new pathways. (NHM, Museum Archives.)

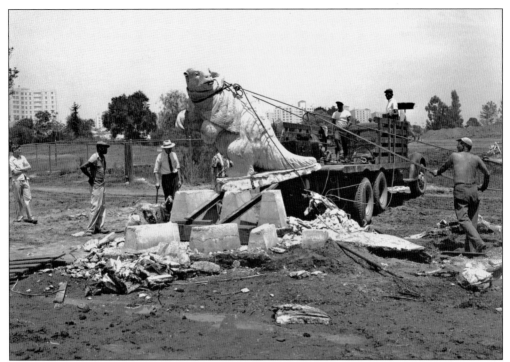

The idea of having a Pleistocene Zoo of statues of the extinct tar pit animals was still considered to be desirable, but no new statuary was created for this park remodel. The existing statues were moved to new locations that were more appropriate for the new landscaping. Here, one of Herman Beck's sloths is being loaded onto a flatbed truck for a ride across the park. (NHM, Museum Archives.)

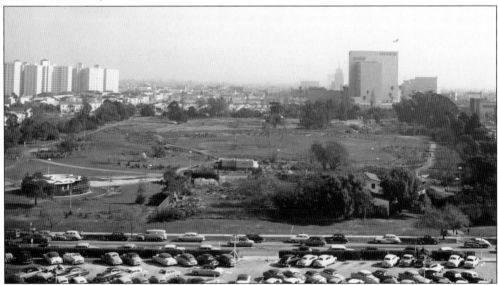

This view of the park was taken from the roof of the May Company Building on August 23, 1951. The new lighting and the Observation Pit have been completed, but the planting has not yet begun. The Park La Brea apartment complex can be seen in the upper left, and the Prudential Building is on the right. (NHM, Museum Archives.)

The new paths curved through the park and over Oil Creek, a natural underground spring that was routed to the surface to become a little stream that supported a population of water snails, crayfish, and other aquatic animals. The old excavation sites were enclosed in new chain-link fences that were more effective in keeping the public away from the tar pits. (NHM, Museum Archives.)

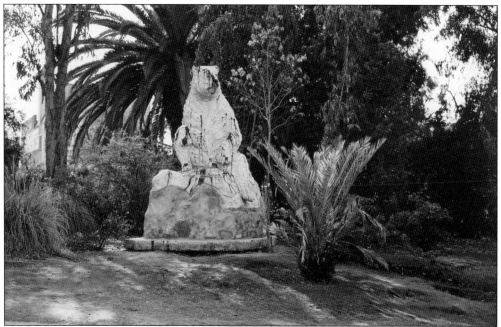

The new landscaping and general sprucing up of Hancock Park did little to prevent the statuary from occasionally being vandalized with splattered tar. Asphalt seeps occur naturally throughout the park, and the flow of tar from any particular seep will increase in warm weather. Sometimes, a seep will stop flowing or change location due to seismic activity. (NHM, Museum Archives.)

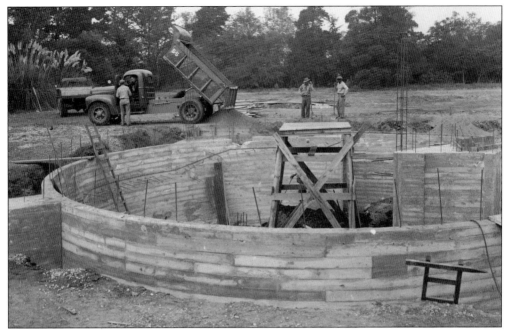

Once Chester Stock located an appropriate fossil deposit, a circular building was designed to enclose it and create a display showing what the fossils looked like when they were still in the ground. This photograph, taken on October 18, 1948, shows the lower section of the concrete walls of the Observation Pit during construction. (NHM, Museum Archives.)

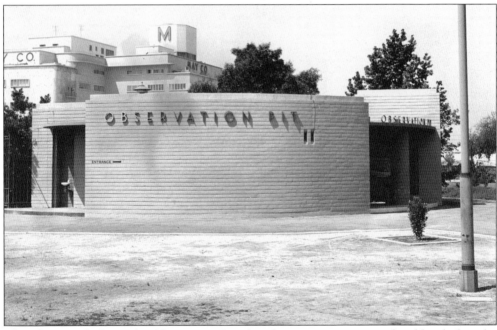

This photograph shows the Observation Pit after the structure was completed but before the landscaping had been installed and the official dedication. The fossil deposit was the only display, and this remained the only fossil museum in Hancock Park until the George C. Page Museum opened in 1977. (NHM, Museum Archives.)

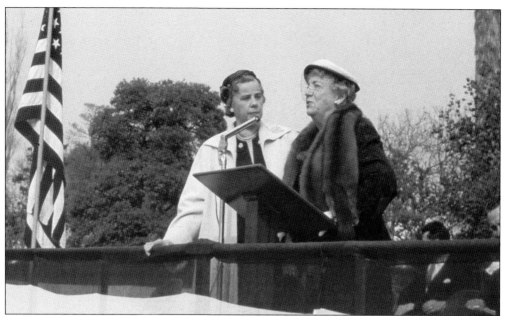

On Sunday, March 11, 1956, a ceremony commemorating the first scientific fossil excavations at La Brea was held in Hancock Park. County Supervisor John Anson Ford was the master of ceremonies, and a roster of distinguished guests attended, many of whom had played a prominent part in the history of Rancho La Brea. Mary Logan Orcutt, seen above with Hildegarde Howard looking on, speaks about the discovery of the fossils made by her late husband in 1901. Other speakers included Dr. Loye Miller, professor of biology emeritus from UCLA; botanist Theodore Payne, who represented the Southern California Academy of Sciences; and museum board member Howard Robinson. During the 1950s, no county ceremony would have been complete without a performance by the Los Angeles County Band, pictured below. (Both, Page Museum Archives.)

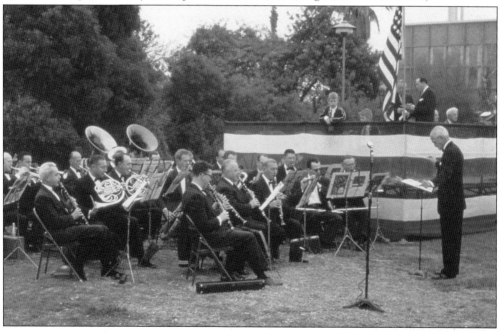

Los Angeles County supervisor John Anson Ford is seen here pointing out something in the Lake Pit to museum director Jean Delacour and chief curator Hildegarde Howard during the park's 50th-anniversary celebration. The Lake Pit is the site of Henry Hancock's asphalt mine that has filled with water. The surface of the water is broken by methane gas bubbles and is covered with floating sheets of tar. (Page Museum Archives.)

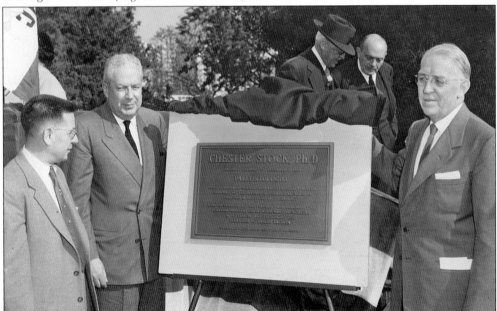

During the 50th-anniversary celebration, the Observation Pit was dedicated in memory of Chester Stock. Dr. Stock died of a stroke on December 7, 1950, and never saw the completion of the park renovations for which he had been the driving force. Here, museum association member Anthony Thormin (left), museum board member William Sesnon (center), and Supervisor John Anson Ford pose next to the Observation Pit plaque. (NHM, Museum Archives.)

In the original design for the Observation Pit, the upper section of the wall was completely open to the outside. It became obvious very quickly that this encouraged vandalism of the fossil display, and modifications were needed to protect the building. Fiberglass panels, with drawings of the extinct La Brea animals by Mary Butler, were installed to make the building more secure. (NHM, Museum Archives.)

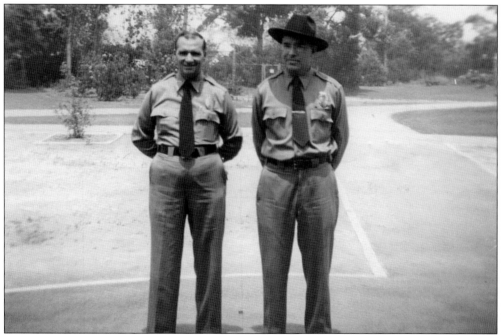

Peter Marsala (left) and Vic Zanoni were hired to be watchmen and tour guides at Hancock Park, and they are seen here in the newly landscaped park in the early 1950s. Zanoni lived in the hacienda until it was torn down in the early 1960s, and he retired from the museum in 1976. (Page Museum Archives.)

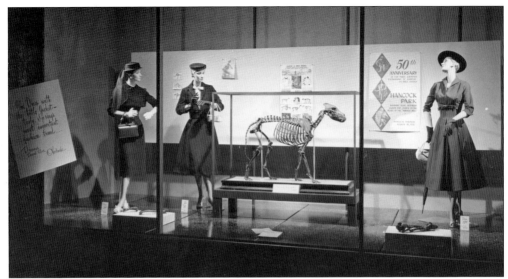

The 50th anniversary of Hancock Park was celebrated outside the park with special displays in the windows of nearby Orbach's department store. The museum loaned the store exhibit items including several mounted La Brea skeletons for the momentous event. The store designed window displays where the fossils shared the space with some of the new spring fashions. The La Brea exhibits were displayed in three of the windows, two of which are pictured here. The fashion mannequins and fossils made for unusual displays, but no record survives of how effective these windows were in selling the new fashion trend, "The Dress with the Little Jacket." The Petersen Automotive Museum is now located in the former Orbach's building. (Both, NHM, Museum Archives.)

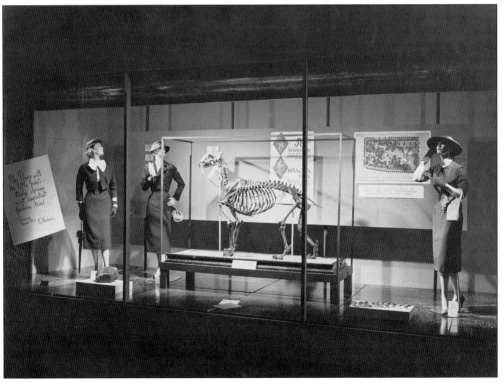

Six

THE 1960s
ART AND FOSSILS

The 1960s brought many changes to Hancock Park, including an art museum, a new fossil excavation, and new statues. Once again, a museum for the fossils was in the works but, once again, it did not come to pass. This rendering of a cyclorama, created on April 12, 1962, is one of the ideas for an exhibit in the Hancock Park paleontology museum. (NHM, Museum Archives.)

Unveiling of a Bust of

CAPTAIN
G. ALLAN HANCOCK

Donor of Hancock Park
To the people of
Los Angeles County

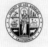

June 13, 1963

On June 13, 1963, a bust of George Allan Hancock was dedicated in the meadow area of Hancock Park. The sculpture honored his donation of Hancock Park to the citizens of Los Angeles County, though the year of the gift is incorrectly noted on the plaque as 1916 instead of 1924. The event also celebrated Hancock's foresight in preserving the fossil site for future generations and the impact that his gift of the fossils had on the Los Angeles County Museum. The photograph shows Supervisor Kenneth Hahn (left) with Hancock, his wife, Marion, and his granddaughter Pat Brennan, with her children Sheila and Jane. (Both, NHM, Museum Archives.)

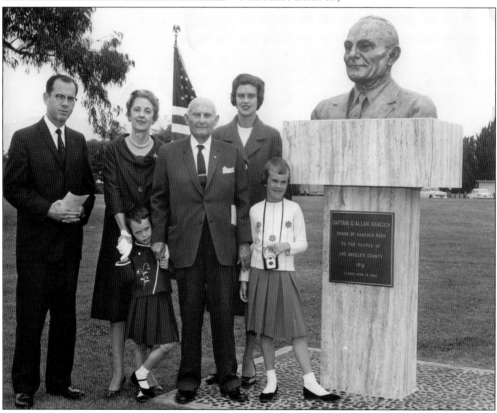

In 1964, Rancho La Brea was recognized as a registered national natural landmark (now a national natural landmark) by the National Park Service and the Department of the Interior. A bronze plaque was installed on a boulder and dedicated in Hancock Park on December 14, 1964, as shown in the above photograph. The speaker is Dr. Herbert Friedman, who had come to the museum as its fifth director in 1961 from the Smithsonian Institution in Washington, DC. Dr. Friedman was a respected scientist specializing in ornithology, and the museum expanded its science programs, including those at La Brea, during his tenure. The bronze plaque is now mounted near the entry to the Page Museum, and the paper certificate, shown in the photograph below, is in the Page Museum Archives. (Both, NHM, Museum Archives.)

United States Department of the Interior ~~~ National Park Service

Rancho La Brea

is hereby designated a

REGISTERED NATURAL
HISTORY LANDMARK

1964

Under the Provisions of the Historic Sites Act of August 21, 1935.
This Site Possesses Exceptional Value in Illustrating the Natural History of the
United States of America

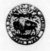

SECRETARY OF THE INTERIOR

DIRECTOR, NATIONAL PARK SERVICE

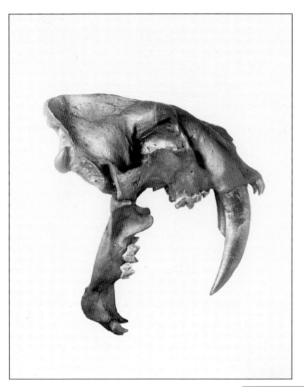

The saber-toothed cat, or *Smilodon fatalis*, is by far the most famous animal from the tar pits. There is no living close relative of this fearsome extinct predator, and although it has been popularly called a tiger in the past, this designation is incorrect. This profile photograph shows a spectacular example of the cat's skull and jaws with the long, saber-like canines. (Page Museum Archives.)

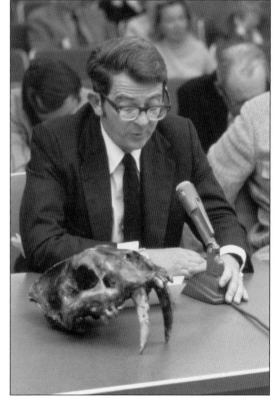

In 1973, the saber-toothed cat became the official state fossil of California, with the statute being signed into law by Gov. Ronald Reagan. At that time, the animal was known as *Smilodon californicus*, but later, research proved it to be identical to the previously named *Smilodon fatalis*. Here, museum director Giles Mead testifies at the hearings in Sacramento. (NHM, Museum Archives.)

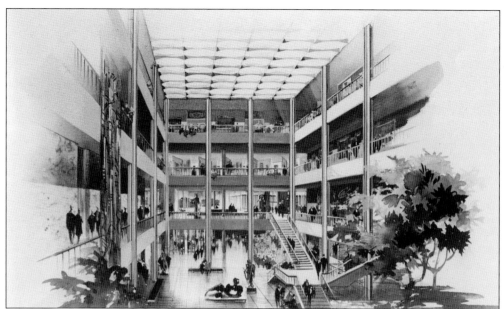

Publicly announced in 1958, the building of an art museum in Hancock Park was an idea that had been first proposed in the 1930s. The art department at the Los Angeles County Museum had long since outgrown its space in the old museum in Exposition Park and needed its own facility to expand its collections and its importance in the art world. Special permission from George Allan Hancock was needed, as his original gift was very specific about what could be done with the La Brea property. Hancock was persuaded to agree to allow the art museum to be built in the park, and the above image is a rendering from 1962 showing the interior atrium of one of the original buildings. The photograph below shows the Los Angeles County Museum of Art during construction, with the Lake Pit in the foreground. (Both, NHM, Museum Archives.)

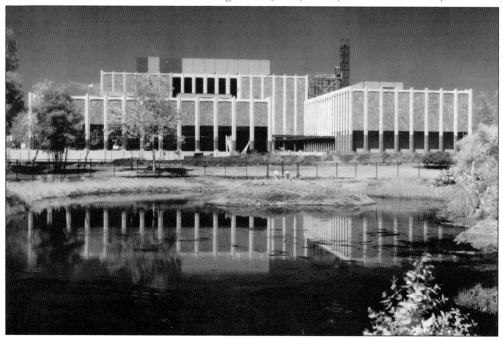

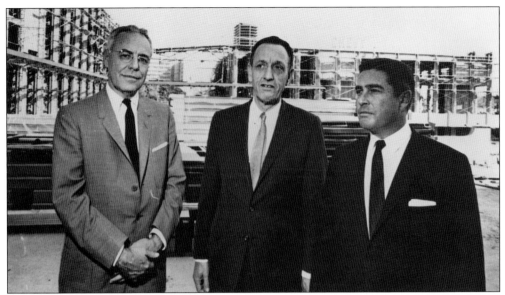

Trustees Edward W. Carter (left), Norton Simon (center), and museum director Rick Brown stand in the central courtyard of the new Los Angeles County Museum of Art during the construction of the original buildings. Simon, a wealthy art collector, later parted company with the new museum and founded his own art museum in Pasadena. (NHM, Museum Archives.)

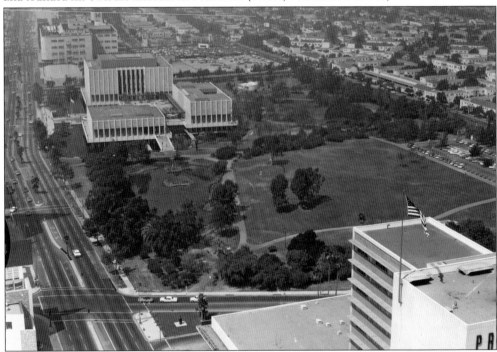

This c. 1964 view of the park clearly shows the completed art museum and the features of the surrounding area. Part of the roof of the Prudential Building can be seen in the lower right, and the May Company is visible above the art museum on Wilshire Boulevard. The Observation Pit, which is the round structure directly behind the art museum, is dwarfed by its new neighbor. (NHM, Museum Archives.)

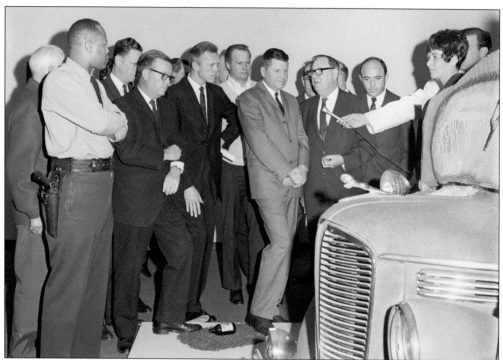

In 1966, the new Los Angeles County Museum of Art hosted an exhibit of works by Edward Kienholz, an artist known for his controversial assemblages. The show caused indignation on the part of the Los Angeles County Board of Supervisors, which deemed the show to be blasphemous and pornographic. Warren Dorn, seen at a press conference (in light-colored suit, clasping hands, near center), led the charge. The piece that most inflamed Dorn was *Back Seat Dodge '38*. (LACMA.)

Throughout the "Backseat Dodge" controversy, the Los Angeles County Board of Supervisors' public outrage left its members wide open for ridicule. The famous *Los Angeles Times* cartoonist Paul Conrad had a field day pointing out the absurdity of their posturing, and he drew a wonderfully wicked series of cartoons, one of which is shown here. In the long run, the flap over *Back Seat Dodge '38* helped put LACMA on the map. (David P. Conrad.)

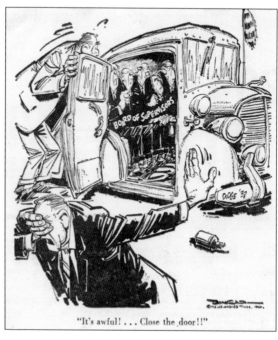

"It's awful! . . . Close the door!!"

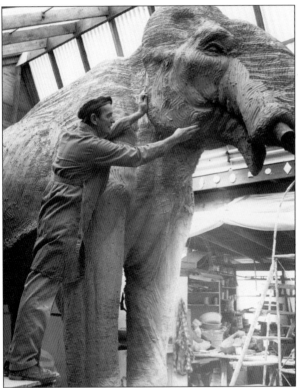

In the 1960s, the museum hired Howard Ball to create new statues for Hancock Park, starting with the Imperial mammoths (now identified more accurately as Columbian mammoths). Ball was a versatile artist who made monsters for Hollywood, animals for rides at Disneyland, and all sorts of industrial designs for utilitarian objects. (NHM, Museum Archives.)

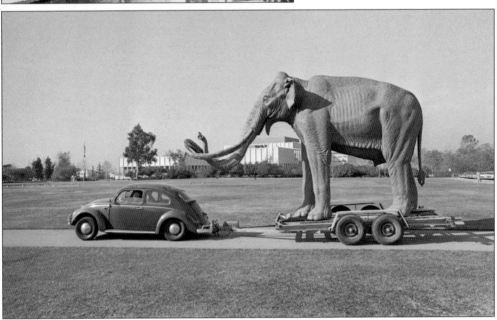

When it came time to move the mammoth sculpture to the park, Howard Ball simply loaded it on a trailer and towed it down Wilshire Boulevard with his Volkswagen bug, no doubt to the amazement of the other drivers and pedestrians who just happened to be there. The sight was so peculiar that photographs made it into the *Los Angeles Times* and *Life* magazine. (UCLA Library, Special Collections, Los Angeles Times Photograph Collection.)

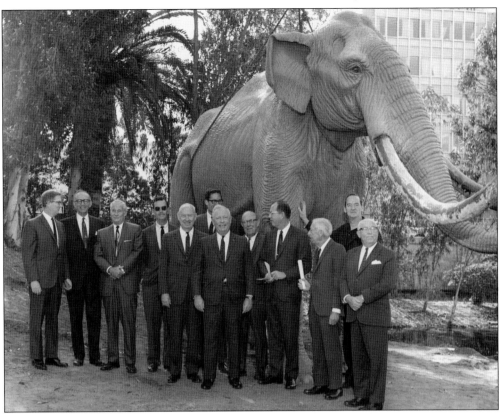

The reproduction of the 13-foot-high male Columbian mammoth was lowered into place on the side of the Lake Pit in January 1967. The fiberglass behemoth was commissioned by William T. Sesnon Jr. and was to be the first of a Pleistocene Zoo consisting of 52 animals. The dignitaries included museum board members, County Supervisor Ernest Debs, and museum director Herbert Friedman. (NHM, Museum Archives, Armando Solis photograph.)

Howard Ball sculpted an entire family of Columbian mammoths, and the statue of the female was installed in Hancock Park on May 29, 1968. Depicting a mammoth trapped in tar, she was designed to float on the surface of the Lake Pit and was attached to a submerged base with two long poles. The statue was lowered into the Lake Pit by a helicopter. (NHM, Museum Archives.)

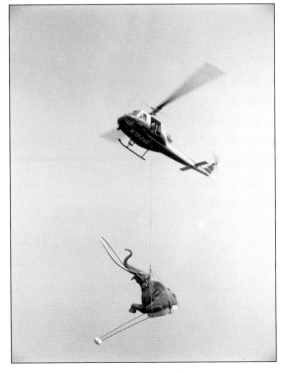

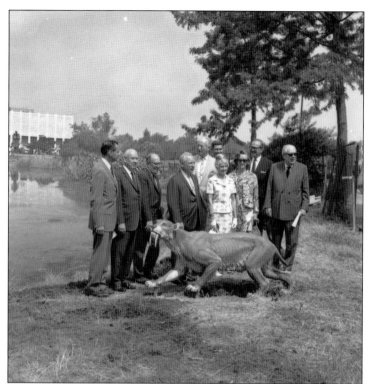

On May 29, 1968, museum trustees and Supervisor Ernest Debs pose with a fiberglass saber-toothed cat in Hancock Park. The new sculptures did not last long, due to several episodes of vandalism and the outright theft of three saber-toothed cats on December 22. A teratorn statue was installed on the bank of the Lake Pit and was stolen after only three days on display. (NHM, Museum Archives.)

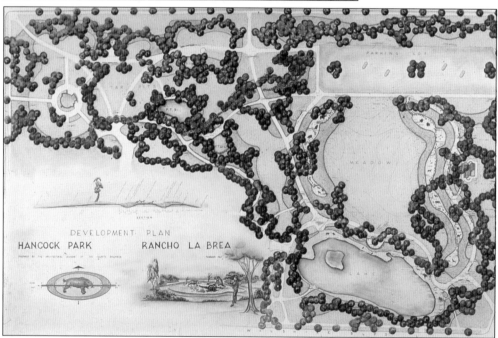

This 1967 map of Hancock Park features animal statues scattered around the park's central meadow, creating a Pleistocene Zoo. The idea was not new and was first proposed in Hancock's original 1916 offer of the land to the county. The constant vandalism and the death of Howard Ball curtailed the 1960s version of this project. (NHM, Museum Archives.)

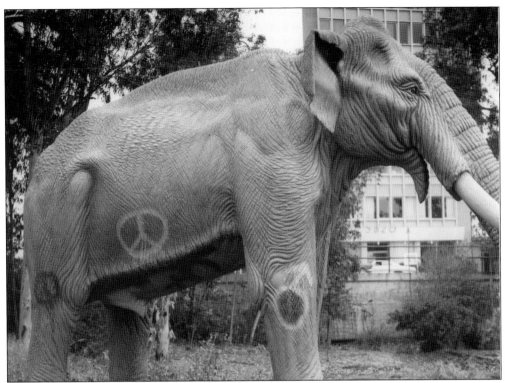

Although the fiberglass pachyderms in Hancock Park are unique and now much loved Los Angeles landmarks, when they were first installed, the statues were targets of vandalism several times. The above photograph shows the male Columbian mammoth covered with graffiti in 1969, and the peace signs and other symbols had to be painted over by the museum's graphic artist Mary Butler. The photograph below shows the mastodon statue, which had been installed on the west bank of the Lake Pit, being towed out of the tarry water. After this bout of vandalism, which occurred in August 1972, the museum filled the legs of the statues with cement to make it more difficult to move them. (Both, NHM, Museum Archives.)

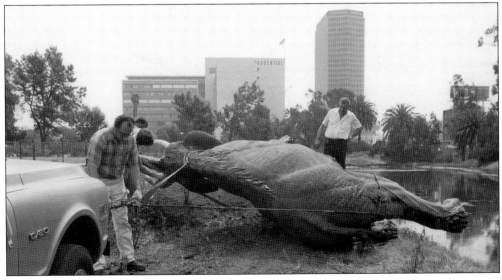

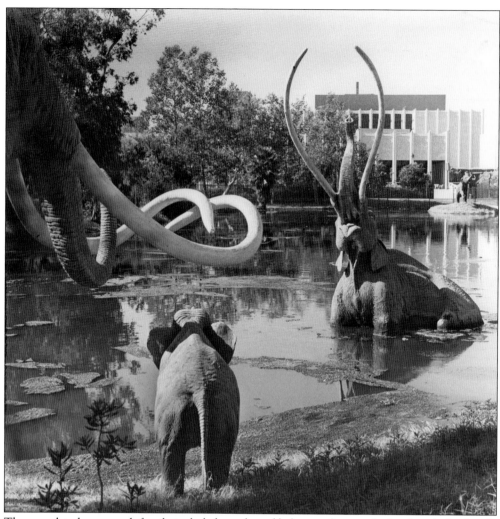

The completed mammoth family included a male and baby standing on the bank with the female mired in the tar pit. A lone American mastodon was installed on an island at the opposite end of the Lake Pit, across from the east entrance to the art museum. Although the scene depicted an entrapment, in reality, the Lake Pit was the depression left by Henry Hancock's 19th-century asphalt quarry and was mostly filled with water. Tar and methane gas seeped up from below the water, forming bubbles and floating patches of asphalt on the water's surface. During rainy years, the Lake Pit had a tendency to overflow its banks, covering the park's walkways and sending muddy, tarry water into the new art museum's sculpture garden. Hancock Park's natural features caused another headache for LACMA. Its decorative reflecting pools that adorned the front of the building tended to fill with liquid asphalt coming from the belowground seeps. (NHM, Museum Archives.)

Seven

Pit 91

A New Search For Fossils

When the art department moved to Hancock Park, the old museum in Exposition Park became the Los Angeles County Museum of Natural History. It retained control of Hancock Park, and in 1969, a decision was made to re-excavate at Rancho La Brea. June 13, 1969, was designated "Asphalt Friday" in honor of the reopening of Pit 91. The ceremonial golden shovel was just for show. (Page Museum Archives.)

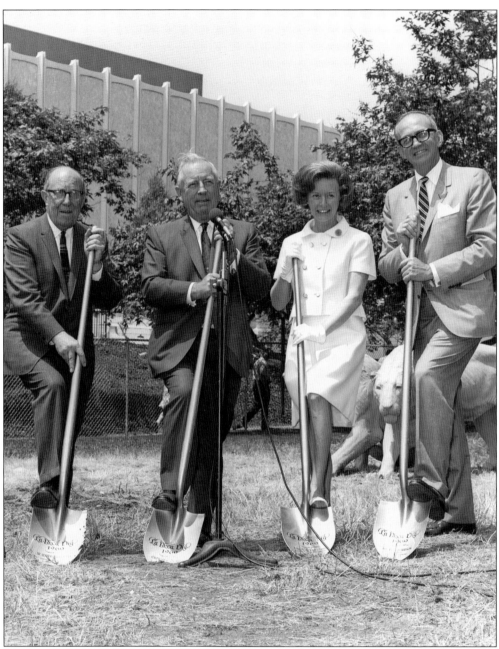

The opening of the first excavation at Rancho La Brea since 1929 created a great deal of excitement and was a major media event. From left to right, museum director Herbert Friedman, County Supervisor Ernest E. Debs, and museum board members Marion Stewart and Ed Harrison pose for a photograph with special golden shovels on Asphalt Friday, June 13, 1969. Pit 91 had been first excavated by the county museum during the 1913–1915 digs and had been deliberately left unfinished at that time. For a while, it was left open as a display pit so park visitors could see what the bone deposits looked like in the ground. Eventually, the pit caved in and was filled with loose sediment and bone. The first task that excavators faced in 1969 was removing this fill so that they could begin work on the undisturbed part of the deposit. (NHM, Museum Archives.)

After the festivities were over, the hard work of digging a large pit fell to a crew of enthusiastic young volunteers. Here, Chris Shaw (left) and Richard Reynolds are starting the excavation of Pit 91. The pit had a layer of disturbed fill that had to be removed before the main deposit could be excavated. Shaw later became the collections manager of the Page Museum. (Page Museum Archives.)

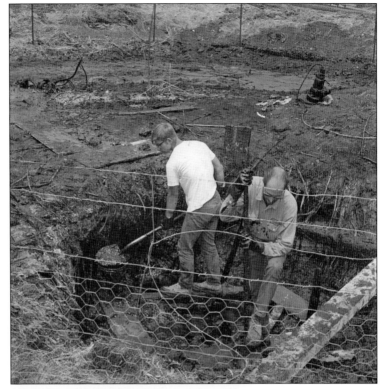

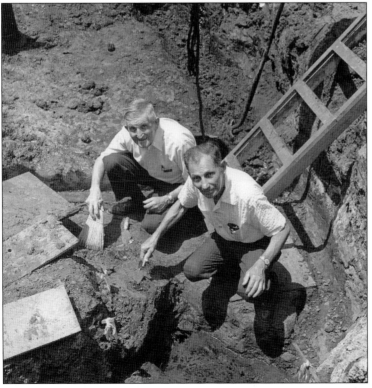

Two surviving workmen from the 1913–1915 excavations, Willard Calderwood (left) and Alex Kagan, visited Pit 91 on July 31, 1969, and posed for pictures. George Miller, Richard Reynolds, and Gretchen Sibley tape-recorded a 45-minute interview with the men and asked them about the early digs. Calderwood and Kagan shared some interesting stories, but they apparently did not remember specifics. Unfortunately, the tape is now missing. (Page Museum Archives.)

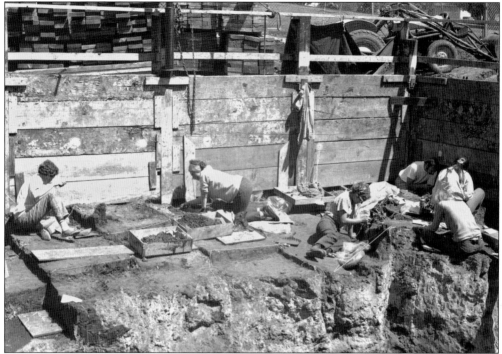

Once the fill was removed and the fossil deposit uncovered, the walls of the excavation were reinforced with heavy boards. This was designed to prevent the surrounding soil from collapsing into the pit, and large metal beams were added for more support. This photograph shows a crew of excavators working in Pit 91 after the shoring boards and I beams had been installed. (Page Museum Archives, Harvey Singer photograph.)

A fenced compound was erected to enclose the Pit 91 excavation site. The pit itself was surrounded by a wooden railing, and the hoist was used for raising buckets of tar and lowering equipment. The sheds in the background were for storing tools, and the trailer was used by the excavators as an office and a place to change into their "pit clothes." (Page Museum Archives.)

Paleontologist George Miller was hired in 1969 to lead the new excavation and served in this position until 1973. Miller was a great promoter and recruited an enthusiastic crew of excavators. He also attracted much attention from the media. He was at odds with some museum staff, however, because he was particularly interested in finding evidence of early man in Pit 91. (Page Museum Archives.)

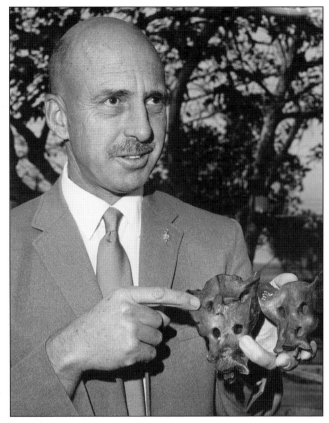

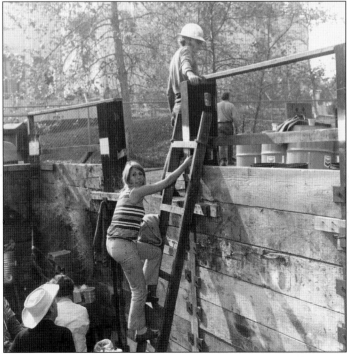

By 1971, the Pit 91 dig was so deep that ladders were required to get in and out. Excavators Dottie Korn and Erich Obermayr are seen climbing out of the pit. A hoist was installed to lift heavy equipment and to remove the endless buckets of the liquid asphalt that the excavators called "glop." (Page Museum Archives, Harvey Singer photograph.)

George Miller was adept at obtaining donations for the Pit 91 excavation, and one of the most important gifts was a complete mountain chalet, or Haida Hide. This building was used as a laboratory facility where the fossils were cleaned, cataloged, and made available for research. The Haida Hide remained in the park until after the laboratory operation moved to the George C. Page Museum. (NHM, Museum Archives.)

The crew of volunteer workers at Pit 91 helped to raise money to defray some of the costs of the excavation. They sold La Brea related souvenirs and books and had donation boxes that encouraged the park visitors to "Help Keep Us Digging Into The Past." Here, the volunteers are painting souvenir rocks at the opening of Haida Hide. (Page Museum Archives.)

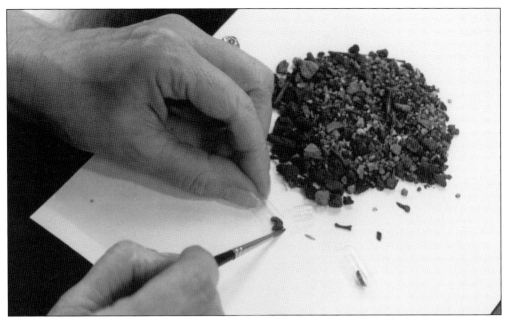

One of the main objectives of the new dig at Pit 91 was to obtain the remains of the small animals that were preserved in the tar pits. The asphalt at La Brea preserves an entire biota, including insects, shells, plant material, and the bones of small mammals and birds. The tarry sediments were collected, cleaned, and sorted for the microfossils, as shown in this photograph. (Page Museum Archives)

On December 8, 1976, a specially designed viewing station at Pit 91 was dedicated with an event that was attended by museum staff, board members, and dignitaries. The new wooden building featured large windows that allowed the park visitors to look directly into the pit and watch the excavators working. Before the viewing station was open, the excavators were only visible when they were outside the pit. (Page Museum Archives.)

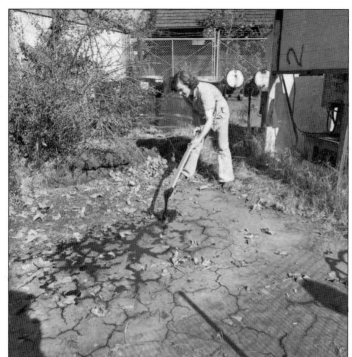

Pit 10, the site where La Brea Woman was found in 1914, was located inside the Pit 91 compound. The seep in Pit 10 formed a circular pool of liquid asphalt, which hardened in cold weather and then became more viscous in the hot summer months. Here, excavator Sharon Metzler is checking out the tar in Pit 10. (Page Museum Archives.)

The asphalt seeps in the park were sometimes camouflaged and difficult to spot. The Berkeley Pit, site of the first excavations at La Brea, was usually covered with a layer of leaves and dirt. In the winter, the surface tar was oxidized and hard enough to walk on. When the hot weather arrived, the asphalt would become more liquid and begin to flow. (Page Museum Archives, Cathy McNassor photograph.)

Mary Romig, seen here in 1987, first came to La Brea as a volunteer excavator in the early 1970s, and she continued to volunteer at the tar pits for over 30 years. She worked both in Pit 91 and in the Page Museum Laboratory, and she organized the museum's Chester Stock Memorial Library. During her tenure at the museum, Mary cataloged over 100,000 fossils. (NHM, Museum Archives.)

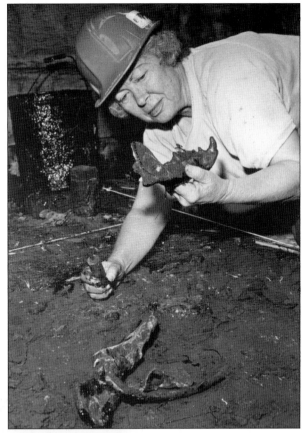

Eric Scott started working as a Page Museum lab volunteer as a 16-year-old high school student. Later, as the chief excavator of Pit 91, he supervised the maintenance of the pit and organized the summer excavation. Eric is shown here in Pit 91 in April 1984. At the time of writing, Eric is curator of paleontology at the San Bernardino County Museum. (NHM, Museum Archives.)

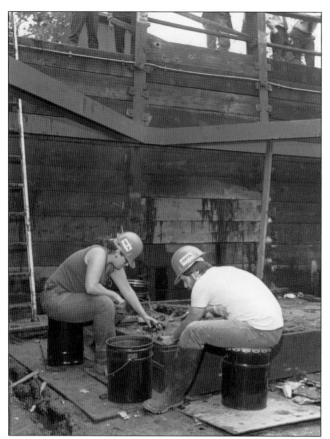

By the late 1980s, the Pit 91 excavation was down below 11 feet, and as the crew dug deeper, the deposit became narrower. Typical La Brea deposits are conical in shape. Antonia Tejada-Flores, shown here with Michael Charters in Pit 91, started at La Brea as a volunteer in 1971. She was later hired as an excavator and was in charge of the summer dig several times. (NHM, Museum Archives.)

Pit 91 was dug year-round from 1969 to 1980. The excavation was reopened in 1984 for two weeks during the Olympics, and this proved to be very popular. A program of excavating in Pit 91 for two months in the summer was begun, and each summer started with a "Media Day" event. Here, Chris Shaw (left) and John Harris pose for the camera in 1997. (NHM, Museum Archives.)

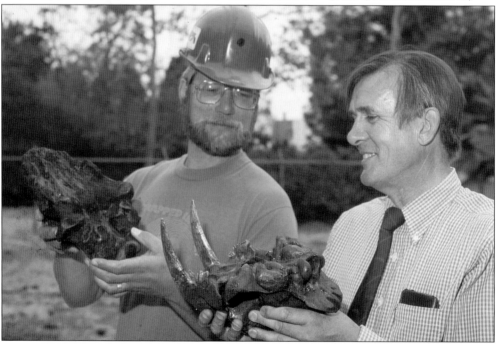

Eight

THE BONES COME HOME
THE GEORGE C. PAGE MUSEUM

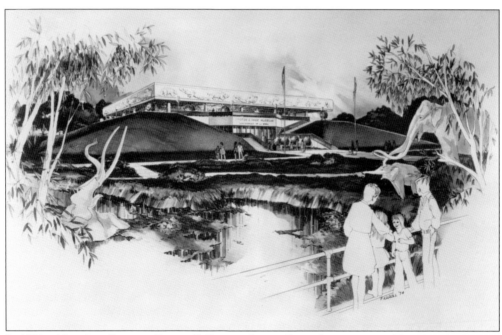

In 1973, self-made millionaire George C. Page made an offer to the museum and Los Angeles County to finance the building of a museum to house the La Brea fossils on the site where they had been discovered. First visiting La Brea in 1917, Page had become fascinated by the place and its incredible story and wanted to share it with the public, especially children. (NHM, Museum Archives.)

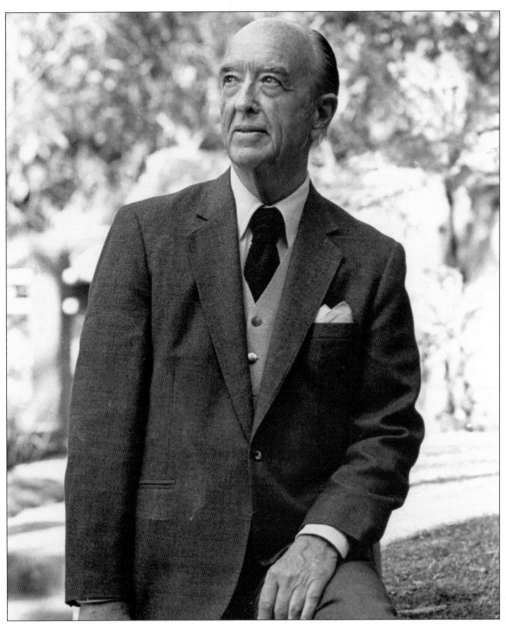

George C. Page left his home in Fremont, Nebraska, at age 16 and hitchhiked to California with $2.30 in his pocket and the determination to make his fortune. Through hard work and an innate gift for marketing and business, Page amassed a considerable fortune. His first company was Mission Pak, which specialized in Christmas fruit baskets, which soon became a Los Angeles holiday fixture. Page's many endeavors included real estate, making automobile bodies, and designing the first industrial park. His beloved wife, Juliette, died in 1968, and he then retired from business and began finding ways to use his money to help others. His philanthropy was largely directed to charities that benefited young people, and he gave considerable gifts to Children's Hospital Los Angeles and Pepperdine College. Page's favorite retirement project was the George C. Page Museum of La Brea Discoveries, which he built for the children of Los Angeles and the world so that they could enjoy the La Brea tar pits as much as he did. (NHM, Museum Archives.)

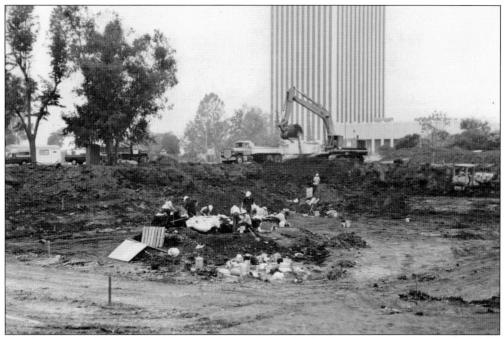

Any hole dug in Hancock Park has a high probability for fossil discoveries. The excavation for the Page Museum building was no exception, and construction was stopped while the fossils were removed. The Page Museum salvage dig, shown here, recovered the first deposit to contain articulated skeletons, rather than the jumbled collection of bones of many animals that is typical for La Brea. (NHM, Museum Archives.)

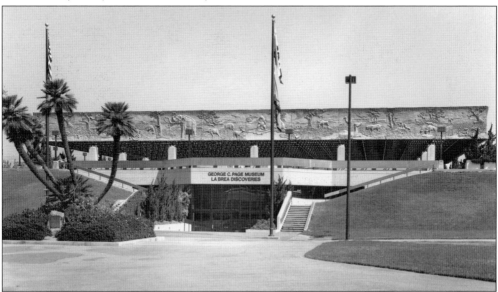

The George C. Page Museum of La Brea Discoveries opened to the public in April 1977 and brought the tar-pit fossils back to Rancho La Brea. This magnificent museum was the dream of philanthropist George C. Page, who became fascinated with La Brea as a young man in 1917. The museum has become a Los Angeles landmark tourist destination for visitors from all over the world. (NHM, Museum Archives.)

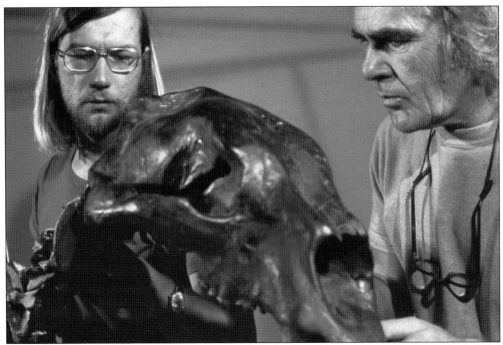

Before the old, mounted skeletons from the Natural History Museum were transferred to the new Page Museum, they needed to be remounted. Master preparator Leonard Bessom (right) had retired from the museum but was rehired to make the new mounts. He was assisted by former excavator Chris Shaw. The new skeletons had their supporting frameworks inside the bones, and they were suspended on wires from the ceiling. (Page Museum Archives.)

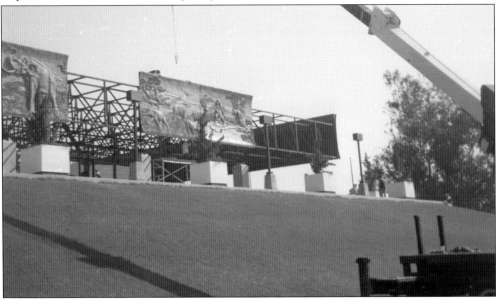

The Page Museum was designed to be partially underground, and the exterior forms a grass pyramid that is topped by a large frieze. The frieze was designed by local artist Manuel Paz, and it took its inspiration from the scenes of La Brea depicted by the 1925 mural by Charles Knight. (Page Museum Archives.)

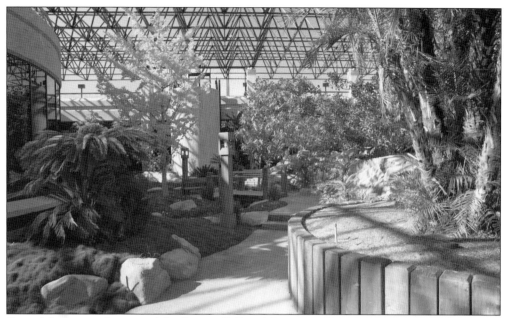

One of the unique features of the George C. Page Museum is the central atrium, which creates a beautiful courtyard that visually opens the building to the outdoors and provides a restful place for visitors to enjoy. The plantings in the atrium were not intended to resemble the flora of the Ice Age, rather George Page loved gardens, and the atrium is a reflection of this passion. (Page Museum Archives.)

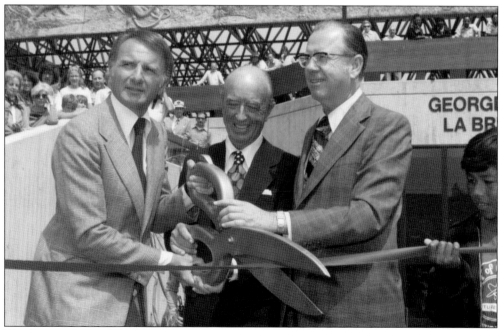

The George C. Page Museum of La Brea Discoveries opened to the public on April 13, 1977. The official ribbon-cutting ceremony was held at 10:00 a.m., and shortly afterwards, Page and hundreds of children led the way into the new museum. Here, George Page (center) cuts the ribbon with the help of County Supervisors Ed Edelman (left) and Kenneth Hahn. (NHM, Museum Archives.)

On October 26, 1977, Prince Charles (left), the 28-year-old bachelor heir to the British throne, visited the new George C. Page Museum and was personally guided through the museum by Page himself. The Prince of Wales was on a goodwill tour of the United States lasting 10 days, three of which were spent in Los Angeles. When Charles arrived at LAX, Mayor Tom Bradley, his wife, Ethel, and other local dignitaries greeted him, and he was whisked by limousine to the Beverly Wilshire, where he was entertained by mariachis, charro riders on horseback, and young girls dressed in senorita costumes. The visit was a nonstop whirlwind of functions, including attending the final test flight of the space shuttle *Enterprise* at Edwards Air Force Base. While at the La Brea tar pits, the prince toured some of Hancock Park as well as the museum. Here, he is shown on the Lake Pit viewing platform with George C. Page (center) and County Supervisor Kenneth Hahn. (NHM, Museum Archives.)

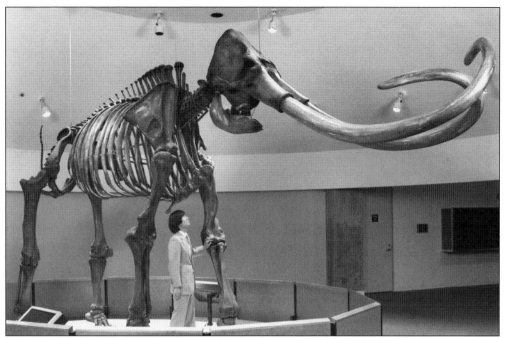

Page brought his expertise in packaging to his museum, and the exhibits were designed to be both accessible and educational. Many of the design features, such as the low railings and circular platforms for the mounted skeletons, were chosen to make it easy for classes of students to see the specimens. Here, George Page's son John Haan poses with the skeleton of a Columbian mammoth. (Page Museum Archives.)

In June 1978, the taxpayers of California overwhelmingly passed Proposition 13, which reduced property taxes and lowered funding for local governments. The Natural History Museum and the Page Museum started charging admission for the first time in October. Here, the author (left) is enlisted by a *Los Angeles Times* reporter to pretend to be the first paying customer of the Page Museum. (UCLA Library, Special Collections, Los Angeles Times Photograph Collection.)

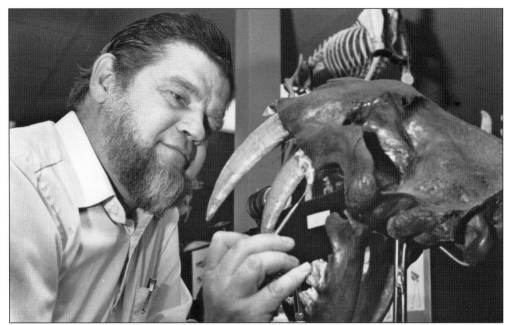

Bill Akersten, curator of the George C. Page Museum, was responsible for making sure that the exhibits in the museum were accurate and educational. Although the final product was outstanding, Dr. Akersten and George Page did not always agree, and this sometimes made the task very difficult. Akersten left the museum in the 1980s to become the curator of vertebrate paleontology at the Idaho Museum of Natural History. (NHM, Museum Archives.)

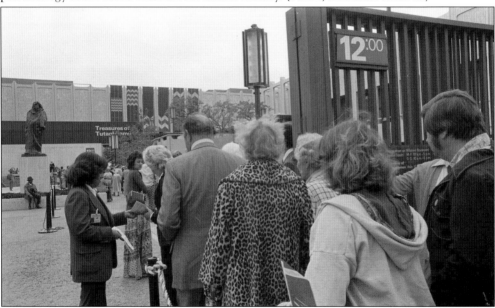

By 1978, the Los Angeles County Museum of Art was well on the way to becoming a major art museum and served as a West Coast venue for important traveling exhibits. The Metropolitan Museum of Art mounted an exhibit of the Treasures of Tutankhamun that generated enormous publicity throughout the country. The Los Angeles run of "Tut" drew crowds that lined up on Wilshire Boulevard. (LACMA.)

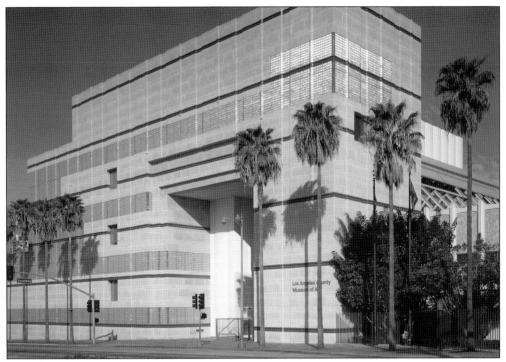

The art museum continued to grow, and in the 1980s, the Wilshire Boulevard side of the museum was completely changed. The new facade was a towering red stone structure that replaced the stepped reflecting pools flanking the entryway in the original design. The Anderson Building, completed in 1986, exhibits modern and contemporary art. (LACMA.)

During the 1984 Summer Olympic Games in Los Angeles, Southern California museums presented special exhibits in conjunction with the Olympic Arts Festival, a program of cultural events affiliated with the games. The arts festival venues were marked with special large stars. LACMA's exhibit was the popular A Day in the Country: Impressionism and the French Landscape, which ran for 11 weeks and was attended by over 400,000 visitors. (Page Museum Archives.)

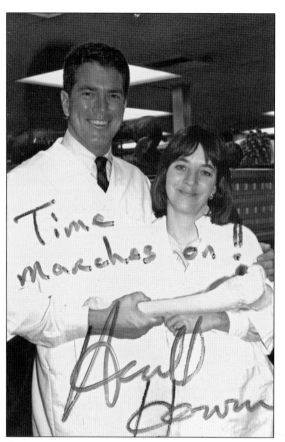

Local public television personality Huell Howser came to the Page Museum in the 1980s to film one of his short programs and is seen here with laboratory supervisor Shelley Cox. In 1995, Huell returned to film an episode of his program, *California Gold*, and he graciously agreed to sign the photograph from his previous visit. (Shelley Cox.)

Gregory Preston Byrd came to the Natural History Museum from the Los Angeles County Chief Administrative Office office in 1974 and was appointed as superintendent of the Page Museum the following year. He became an expert on the tar pits and Hancock Park and gave most of the VIP tours during his years at the Page Museum. Byrd (left) is seen here with the veteran reporter and CBS anchorman Walter Cronkite. (Page Museum Archives.)

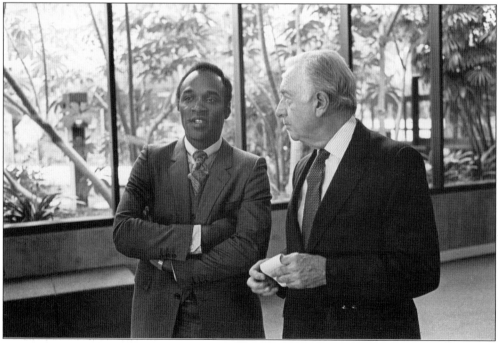

Chief excavator Eric Scott (left), associate curator George Jefferson (third from left), and laboratory supervisor Shelley Cox (right) pose with David Attenborough during a break in filming of *Lost Worlds, Vanished Lives* in the Page Museum Laboratory on March 25, 1988. Numerous educational television programs have been filmed at the George C. Page Museum, and the science staff has become adept at performing for the camera. (NHM, Museum Archives, Don Meyer photograph.)

Former Speaker of the House Newt Gingrich dropped by the Page Museum for a private tour in August 1998. The laboratory staff was surprised and impressed with Gingrich's interest in and knowledge of paleontology and the well thought-out questions that he asked while on the tour. Here, Chris Shaw (right) is explaining a feature of a horse skull to Gingrich. (NHM, Museum Archives, Dick Meier photograph.)

The Page Museum celebrated its 10th anniversary on Friday, April 10, 1987, with a party at 10:00 a.m. that was open to the public. Museum director Craig Black (left) and George C. Page pose with a special cake that was later cut and served to attending staff and visitors. After the slicing of the cake, Page personally guided a group of schoolchildren on a tour of his museum and answered questions about the tar pits. Two newly discovered fossils that had been recovered from a deposit under Wilshire Boulevard were put on special exhibit for this event. One particularly nice specimen was the jaw of an American lion, a large cat that is relatively rare at La Brea. During its first 10 years of operation, the Page Museum had five million visitors from all over the world. By 1987, the admission charge for adults was $3. (NHM, Museum Archives, Don Meyer photograph.)

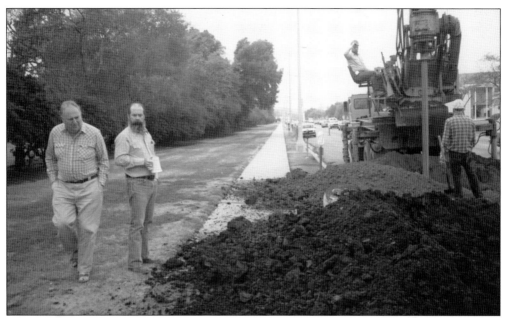

The La Brea tar seeps are not confined to the 23-acre Hancock Park, and asphalt often bubbles up from below streets and buildings in the surrounding neighborhoods. Here, Leslie Marcus (left), a curator from the American Museum of Natural History in New York, and George Jefferson inspect a pile of dirt brought up by an auger on Sixth Street. They are standing in Hancock Park, on the northeast side. The city was drilling to install a sump and hit fossils. (Page Museum Archives.)

Laboratory supervisor Shelley Cox (rear) checks on her crew while they are picking fossils out of 15 tons of dirt that had been brought up by an auger from under Wilshire Boulevard and then dumped in the park. The deposit had been discovered earlier by the gas company, and its drilling left a belowground fissure that created a new seep. The auger was used to put in a new sump. (Shelley Cox.)

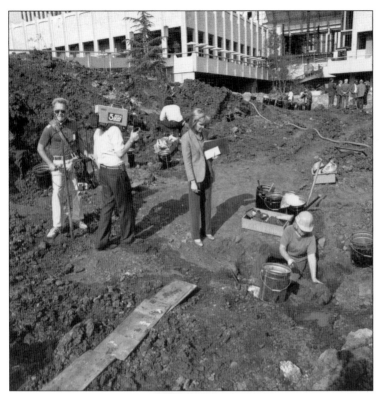

In 1986, LACMA broke ground for a new building, the Pavilion for Japanese Art. Soon after construction began, an enormous fossil deposit was discovered, and the project was temporarily halted while the paleontologists rushed to remove the bones. The fossils apparently had been displaced during the building of the original art museum and were not in situ. The dig was very popular with the local news media. (NHM, Museum Archives.)

John Harris, chief curator of earth sciences at the Natural History Museum, was in charge of La Brea, and is seen at right showing a fossil to Page Museum superintendent Greg Byrd and archaeologist Roy Salls (seated). The huge size of the deposit and the speed with which it needed to be removed made it necessary to recruit as many excavators as possible. (NHM, Museum Archives.)

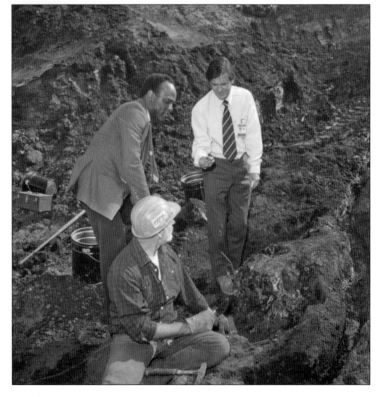

Greg Byrd (left) and George Jefferson stand behind a table covered with specimens that were collected during the Japanese Pavilion salvage dig. This excavation yielded a historical site as well as the usual fossils. The bottles, license plate, and other artifacts on the table came from what appeared to be a dump from the early 1900s. (NHM, Museum Archives.)

The Pavilion for Japanese Art was designed by Bruce Goff to house the Japanese art collection of Joe and Etsuko Price. Goff died in 1982 and did not see the completed structure, which opened to the public in 1988. Architect Bart Prince completed the schematic design. This is a view of the pavilion from the bank of the Lake Pit. (Page Museum Archives.)

109

Although the tar pits are now surrounded by a major city, small animals still fall victim to the sticky asphalt. Laboratory supervisor Shelley Cox is often called upon to rescue trapped birds from the pits, and she is seen here on the side of the Lake Pit with her "pigeon pole." (Page Museum Archives.)

Barbara Parkhurst began her long career at La Brea as a Hancock Park volunteer tour guide in the early 1970s, after she had completed the Natural History Museum docent-training classes. She is shown here standing next to the statue of the short-faced bear in 1973. Barbara Parkhurst was in charge of the tour-guide program at the Page Museum until her retirement in 1992. (Page Museum Archives.)

Longtime volunteer Richard Sapiro is seen here in the fishbowl lab. He worked on many projects at the Page Museum, including the cataloging of fossils from Pit 91. Sapiro cataloged the Page Museum's book collections and assisted the staff in its research, often being asked to locate obscure publications in local university libraries. (Page Museum Archives.)

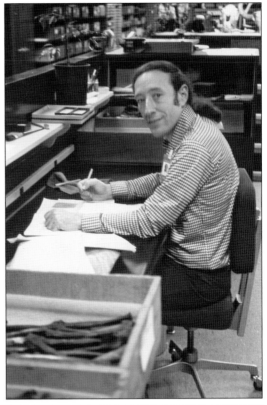

Charlie Cox began performing in front of the Page Museum shortly after it opened in 1977 and still performs for museum visitors 34 years later. He plays guitar, banjo, and mandolin and is famous for teaching school classes how to dance the Virginia reel before their tours of the museum. Charlie Cox's song "Allan Hancock Had a Tar Pit" was featured in an episode of *California Gold*. (Cathy McNassor photograph.)

The laboratory staff, lab volunteers, and the Page Museum tour guides threw a party for George Page's 96th birthday in June 1997. John Harris and Page are seen here admiring the huge full-sheet cake that was ordered specially for this event from the Phoenix Bakery in Chinatown. (Page Museum Archives, Jack Weinger photograph.)

Page Museum Laboratory volunteer Mary Romig was named the County Volunteer of the Year for the Natural History Museum in 1987. At a ceremony at the music center, Mary received a special scroll signed by the Los Angeles County Board of Supervisors in recognition of her service to Los Angeles County. Those pictured are, from left to right, Greg Byrd; George Jefferson; Mary; her husband, Bob Romig; Chris Shaw; and Shelly Cox. (Page Museum Archives.)

Throughout Hancock Park, and also in some of the adjacent streets, underground sumps help keep the tar from overflowing onto the pavement and making a sticky mess. The sumps are actually large metal tubes with holes in the sides. The tubes are installed belowground near active seeps, and the liquid asphalt flows into the sump through the holes. (Page Museum Archives, Jerry Smith photograph.)

The sumps regularly fill up with liquid asphalt that must be removed before the sump overflows. Several times a year, a pumper truck makes the rounds and drains each of the sumps in the park. The excess tar is also pumped out of the Pit 91 excavation and the Observation Pit. (Page Museum Archives.)

Hancock Park and the La Brea tar pits have often been used as film locations, and sometimes the site figures heavily in the plots of the films. In 1987, the motion picture *Miracle Mile* did location shooting in Hancock Park for several days. The movie was billed as a romantic disaster movie, and the plot revolved around an impending nuclear attack that was directed at Los Angeles. One of the scenes in the movie featured a helicopter flying low over the Lake Pit, and during the takes for this scene, the female mammoth was knocked off her base by the vibrations of the helicopter's rotor. (Both, NHM, Museum Archives, Don Meyer photographs.)

The exhibits division staff members of the Natural History Museum attempted to put the female mammoth statue back on her base, but their efforts were unsuccessful, and she continued to float around the Lake Pit. On the second try, the mammoth was anchored to the bank with steel cables, which succeeded in keeping her in place. Joe Cocke (left) and Chuck Fischer use an inflatable boat to navigate through the muck and tar on the surface of the water. After they were finished anchoring the mammoth, Joe Cocke took Shelley Cox for a boat ride around the Lake Pit (below). The inflatable boat was covered in tar by the time this project was done and was discarded. (Both, Page Museum Archives, Cathy McNassor photographs.)

INTERNATIONAL *festival* of masks

Sunday, October 28, 1990
11:00 AM to dusk
Hancock Park

The Craft and Folk Art Museum is on the corner of Wilshire Boulevard and Curson Avenue, directly across the street from the Page Museum. Opened in the 1960s as the Egg and the Eye restaurant, it evolved into a museum that showcases ethnic art and American crafts. For many years, the Craft and Folk Art Museum produced the popular Festival of Masks in Hancock Park. (Page Museum Archives.)

In 1994, the Natural History Museum opened the Petersen Automotive Museum to showcase its collection of historic vehicles. The Los Angeles County Museum started collecting cars in 1929, and this satellite museum was dedicated to all facets of automotive history. The Petersen Museum is located on the corner of Wilshire Boulevard and Fairfax Avenue in the Orbach's Building. In 2000, the Petersen became an independent institution. (NHM, Museum Archives.)

Nine

INTO THE 21ST CENTURY
LA BREA CONTINUED

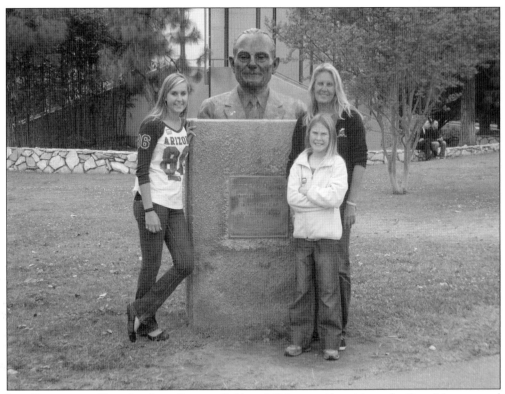

Jane Brennan and her daughters Brenna (left) and Sidney paid a visit to the Page Museum and Hancock Park in 2010 and pose with the bust of George Allan Hancock. Jane is Hancock's great-granddaughter, and family members are very proud of the role their ancestors played in the history of Los Angeles and the La Brea tar pits. (Jane Brennan photograph.)

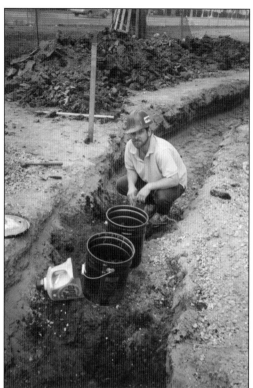

During the late 1990s, Hancock Park underwent extensive renovations that changed much of the existing landscape. Updated plantings and paths were included in the new plans, and the excavations and grading operations uncovered fossil deposits that needed to be removed. Sam McLeod, the collections manager of vertebrate paleontology at the Natural History Museum, was enlisted to help with the salvage excavation. (Page Museum Archives, Jerry Smith photograph.)

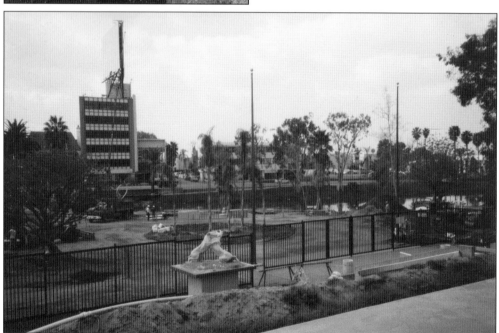

The paved space in front of the Page Museum was totally redesigned, the old Lake Pit viewing station was removed, and the fence was moved closer to the Lake Pit. Picnic tables, restrooms, and vending machines were installed to one side of the entry to the Page Museum, creating a place for visiting school groups to have their lunches. (Page Museum Archives, Jerry Smith photograph.)

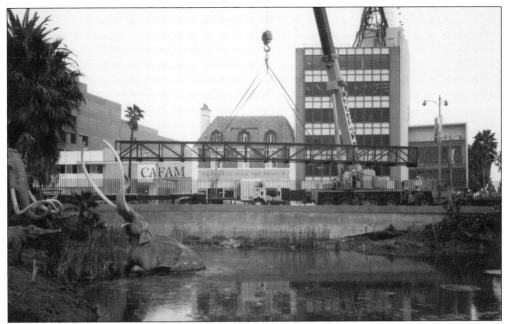

A new bridge was installed along the Wilshire Boulevard side of the Lake Pit, allowing visitors a chance to view the park from a different angle. The entire park was enclosed by a perimeter fence so that the property could be shut at night. Once this fence was installed, the one surrounding the Page Museum was removed. (Page Museum Archives, Jerry Smith photograph.)

Museum benefactor George C. Page died on November 28, 2000, at age 99. In June 2001, the Page Museum held a celebration of what would have been Page's 100th birthday. Chief curator John Harris (left) and Page's son John Haan pose for this picture after the ceremony. (Page Museum Archives, Dick Meier photograph.)

After Hancock Park was relandscaped, the Page Museum education staff designed and installed a Pleistocene Garden at the west end of the parking lot. The garden featured the types of plants that grew at La Brea during the Ice Age and was based on the fossil seeds and other plant material recovered from the excavation of Pit 91. (Cathy McNassor photograph.)

The new Hancock Park landscaping included a high-walled compound to enclose dumpsters for the Page Museum and park and to conceal these unattractive trash containers. The large expanse of wall was perfect for a mural to complement the adjacent Pleistocene Garden. Museum habitat group background artist Robert Reid painted a beautiful mural depicting the La Brea landscape during the Ice Age on the trash enclosure. (Cathy McNassor photograph.)

LACMA purchased the May Company Building on Wilshire Boulevard and Fairfax Avenue and renamed it LACMA West. This endeavor joined Hancock Park with the May Company property by removing a street and an old parking structure. The excavation for a new underground parking structure was extensive and uncovered 16 large fossil deposits. (Robin Turner, ArchaeoPaleo Resource Management.)

In addition to asphalt and methane, La Brea seeps sometimes can produce deadly hydrogen sulfide gas. Robin Turner, president and principle investigator of ArchaeoPaleo, a company specializing in monitoring construction sites for fossils, archaeological and historical artifacts and human remains, is wearing a protective gas mask. Hydrogen sulfide was encountered during construction of the art museum's new underground parking structure. (Robin Turner, ArchaeoPaleo Resource Management.)

Large fossil deposits uncovered during LACMA's parking structure construction were relocated for careful scientific excavation. To accomplish this feat, Robin had giant "tree boxes" built to enclose the fossils in their matrix. After the deposits were boxed, they were loaded on a flatbed truck and moved to the Pit 91 compound. (Robin Turner, ArchaeoPaleo Resource Management.)

The new building project at LACMA was called a "transformation," and it seamlessly joined the older buildings in Hancock Park with the new facilities. The exhibition space was greatly increased with the opening of the Broad Contemporary Art Museum in 2008 and the Lynda and Stewart Resnick Exhibition Pavilion in 2010. The Chris Burden installation *Urban Light* has become a new Los Angeles landmark. (LACMA.)

Many of the Project 23 boxes containing the fossil deposits from the art museum parking structure construction site are so large that the excavators have to climb inside them to get to the fossils. The scaffolding makes this possible, and the covers over the boxes provide much-needed shade. (Cathy McNassor photograph.)

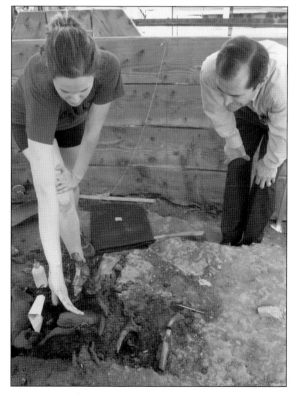

Brett Arena, the archivist for the A.F. Gilmore Company, visited the Page Museum, and he was taken on a tour of Hancock Park. One of the highlights of the tour was the Pit 91 compound, where he was shown the pit and the Project 23 boxes. Here, excavator Christina Lutz explains the process of removing bones from the matrix. (Cathy McNassor photograph.)

Trevor Valle, laboratory assistant for the Page Museum, colors in the pelvis on a diagram of Zed the mammoth in the fishbowl lab. Museum visitors learn which bones have been cleaned by bones filled in on the diagram. Columbia mammoth Zed was found in the Project 23 salvage excavations. The skeleton is partially articulated and 80-percent complete. (Page Museum photograph.)

Chris Shaw retired from the Page Museum in 2010, and his assistant Aisling Farrell was promoted to the collections manager position. Originally from Ireland, Aisling has worked in the Page Museum education division and then for the Dinosaur Institute at the Natural History Museum. She returned to the Page Museum as the curatorial assistant for Project 23. Aisling is shown here working in the fishbowl lab. (Page Museum photograph.)

Gary Takeuchi started his association with La Brea as a volunteer in the Page Museum Laboratory, and he also volunteered in the Pit 91 excavation. He became chief excavator of the summer dig and was later curatorial assistant of vertebrate paleontology at the Natural History Museum. Gary returned to the Page Museum as a curatorial assistant in 2011, and he is seen here computerizing Pit 91 data. (Cathy McNassor photograph.)

Trino Marquez, shown here with sales associate Avery Roper (right), came to the Page Museum in 2002 to manage the gift shop. His astute marketing sense and creative choice of merchandise provides an interesting selection of products for the museum visitors. Marquez became the store director of all the Natural History Museum's retail operations in 2008. (Cathy McNassor photograph.)

Museum trustee Betty Reddin (second from left) and Page Museum head of education Margi Bertram (third from left) join Tim Lawson and his friend Becky Ann for a late-afternoon walk in the park. Hancock Park serves as a peaceful oasis in an intensely urban setting and provides a place for visitors to relax and enjoy its unique features. The park is a place to walk one's dog, bring children to play, or just sit in the sun. In its 23 acres, there are always amazing new things to discover. No other place has both one of the world's great art museums and the world's richest Ice Age fossil site all within a short walk. The fascination of the La Brea tar pits continues unabated, as does the research into the lives of the animals that lived and died here thousands of years ago. (Cathy McNassor photograph.)

BIBLIOGRAPHY

Bryan, William Alanson. "A Pleistocene Park in the Making." *Museum Graphic*, January-February 1927.

Clover, Sam T. *A Pioneer Heritage*. Los Angeles: Saturday Night Publishing, 1932.

Collins, Holdridge Ozro. "Editorial." *Bulletin of the Southern California Academy of Sciences* XIV (1915): 4–7.

Denton, William. "On the Asphalt Beds Near Los Angeles, California." *Proceedings of the Boston Society of Natural History* 18 (1875): 185–186.

Harris, John M., ed. *Rancho La Brea: Death Trap and Treasure Trove*. Los Angeles: Natural History Museum of Los Angeles County, 2001.

Lytle, J.W. "The Rancho La Brea Asphalt Pits." *Museum Graphic*, September-October 1926.

Merriam, John C. "Death Trap of the Ages." *Sunset*, October 1908.

Newmark, Harris and others. *Sixty Years in Southern California: 1853–1913, fourth edition*. Los Angeles, CA: Dawson's Book Shop, 1984.

Page, George C. *In My Own Words*. Glendale, CA: Griffin, 1993.

Sibley, Gretchen. *La Brea Story*. Los Angeles: Los Angeles County Museum of Natural History, 1967.

Stock, Chester. *Rancho La Brea, a Record of Pleistocene Life in California*. Science Series 1. Los Angeles: Los Angeles County Museum, 1930.

Stock, Chester. Revised by John M. Harris. *Rancho La Brea, a Record of Pleistocene Life in California*. Science Series 37. Los Angeles: Natural History Museum of Los Angeles County, 1992.

Wyman, L.E. "La Brea in Retrospect." *Museum Graphic*, January-February 1927.

www.arcadiapublishing.com

Discover books about the town where you grew up, the cities where your friends and families live, the town where your parents met, or even that retirement spot you've been dreaming about. Our Web site provides history lovers with exclusive deals, advanced notification about new titles, e-mail alerts of author events, and much more.

MADE IN THE

Arcadia Publishing, the leading local history publisher in the United States, is committed to making history accessible and meaningful through publishing books that celebrate and preserve the heritage of America's people and places. Consistent with our mission to preserve history on a local level, this book was printed in South Carolina on American-made paper and manufactured entirely in the United States.

This book carries the accredited Forest Stewardship Council (FSC) label and is printed on 100 percent FSC-certified paper. Products carrying the FSC label are independently certified to assure consumers that they come from forests that are managed to meet the social, economic, and ecological needs of present and future generations.

FSC
Mixed Sources
Product group from well-managed
forests and other controlled sources

Cert no. SW-COC-001530
www.fsc.org
© 1996 Forest Stewardship Council

Find *Your* Place in History.